Simple Stroke

CALLIGRAPHY

...he making of letters in every form

is for me the purest and the greatest

pleasure, and at many stages of my

life it was to me what a song is to

...inger, a picture to the painter

... the elated... or a sigh to the...

ABCDEFGhIJKLMNOPQRSTUVWXY

WORKER, FOR THE BUSINESSMAN AS
AS FOR THE MAN WHO WRITES LETTE
FOR EXAMPLE, A SOOTHING, CALMIN
INFLUENCE ON THE MIND, SOMETHING
GOOD ARMCHAIR WHICH PROVIDES
RELAXATION FROM PHYSICAL FATIGUE

HENRY MATISSE

abcdefghijklmn...

You who employ your time to make...
make their glory great among your groves and...
flow, waters the soul of groves and flowers too.

Ra...

HOLD...
...KEEP YOUR DREAMS! WITHIN YOUR HEART. KEEP ONE STILL SECR...
...A PLACE APART. WITHIN YOUR HEART. FOR LITTLE DREAMS TO...
...AT SORROW. MAKE BELIEVE! FORGET THE CALM. THAT LIES IN DISILLUSION...
...IMMORALITY. WE SEE SO MANY UGLY THINGS. DECEITS AND WRONGS AND...
...BLOOM UPON THE FLOWER. THE BLOOM UPON THE BREAST. AND YOUTH'S BLIND HOUR. YET KE...
...HOLD FAST. HOLD FAST YOUR DREAMS. LOUISE DRISCOLL. HOLD FAST. HOLD FAST YOUR DR...

When you
come to the end
of a perfect day
and you sit
alone with your
thought; while
the chimes ring
out with a
carol gay for
the joy that
the day has
brought.

Simple Stroke
CALLIGRAPHY

Marci Donley

Sterling Publishing Co., Inc.
New York

Prolific Impressions Production Staff:
Editor in Chief: Mickey Baskett
Copy Editor: Phyllis Mueller
Graphics: Dianne Miller, Karen Turpin
Styling: Lenos Key
Photography: Jerry Mucklow
Administration: Jim Baskett

Every effort has been made to insure that the information presented is accurate. Since we have no control over physical conditions, individual skills, or chosen tools and products, the publisher disclaims any liability for injuries, losses, untoward results, or any other damages which may result from the use of the information in this book. Thoroughly read the instructions for all products used to complete the projects in this book, paying particular attention to all cautions and warnings shown for that product to ensure their proper and safe use.

No part of this book may be reproduced for commercial purposes in any form without permission by the copyright holder. The written instructions in this book are intended for the personal use of the reader and may be reproduced for that purpose only.

Library of Congress Cataloging-in-Publication Data:
Donley, Marci.
 Simple stroke calligraphy / Marci Donley.
 p. cm.
 Includes index.
 ISBN 1-4027-1479-3
1. Calligraphy. I. Title.

243.0667 2006
745.6'1--dc22

2005025306

10 9 8 7 6 5 4 3 2

Published by Sterling Publishing Co., Inc.
387 Park Avenue South, New York, N.Y. 10016
©2006 by Prolific Impressions, Inc.
Produced by Prolific Impressions, Inc.
160 South Candler St., Decatur, GA 30030
Distributed in Canada by Sterling Publishing
c/o Canadian Manda Group, 165 Dufferin Street
Toronto, Ontario, Canada M6K 3H6
Distributed in the United Kingdom by GMC Distribution Services,
Castle Place, 166 High Street, Lewes, East Sussex, England BN7 1XU
Distributed in Australia by Capricorn Link (Australia) Pty. Ltd.
P.O. Box 704, Windsor, NSW 2756, Australia

Printed in China
All rights reserved

Sterling ISBN 13: 978-1-4027-1479-5
 ISBN 10: 1-4027-1479-3

For information about custom editions, special sales, premium and corporate purchases, please contact Sterling Special Sales Department at 800-805-5489 or specialsales@sterlingpub.com.

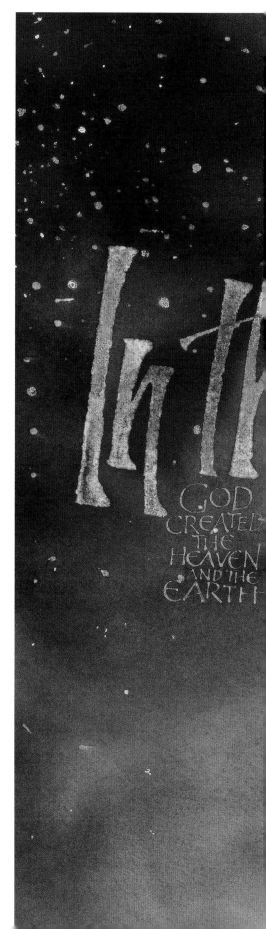

Calligraphy by Carol Hicks, Roman alphabet done with ruling pen and steel nibs in gouache

Calligraphy on title page by Fred Tauber

e beginning

AND THE EARTH WAS WITHOUT FORM, AND VOID;
AND DARKNESS WAS UPON THE FACE OF THE DEEP.
AND THE SPIRIT OF GOD MOVED
UPON THE FACE OF THE WATERS.
AND GOD SAID, "LET THERE BE LIGHT"
AND THERE WAS LIGHT. AND GOD
SAW THE LIGHT WAS GOOD,
AND GOD DIVIDED THE LIGHT FROM THE DARKNESS.
AND GOD CALLED THE LIGHT DAY, AND
DARKNESS HE CALLED NIGHT. AND THE EVENING
AND THE MORNING WERE THE FIRST DAY.
THEN GOD SAID "LET THERE BE AN EXPANSE
IN THE MIDST OF THE WATERS, AND LET IT
SEPARATE THE WATERS FROM THE WATERS.
AND GOD MADE THE EXPANSE AND SEPARATED THE WATERS WHICH
WERE BELOW THE EXPANSE FROM THE WATERS
WHICH WERE ABOVE THE EXPANSE; AND IT WAS SO.
AND GOD CALLED THE EXPANSE HEAVEN.
AND THERE WAS EVENING, AND THERE WAS MORNING,
A SECOND DAY. THEN GOD SAID,
LET THE WATERS BELOW THE HEAVENS BE GATHERED
INTO ONE PLACE AND LET THE DRY LAND APPEAR,
AND IT WAS SO. AND GOD CALLED THE DRY LAND EARTH
AND THE GATHERING OF THE WATERS HE CALLED SEAS
AND GOD SAW THAT IT WAS GOOD.

C O N T

E N T S

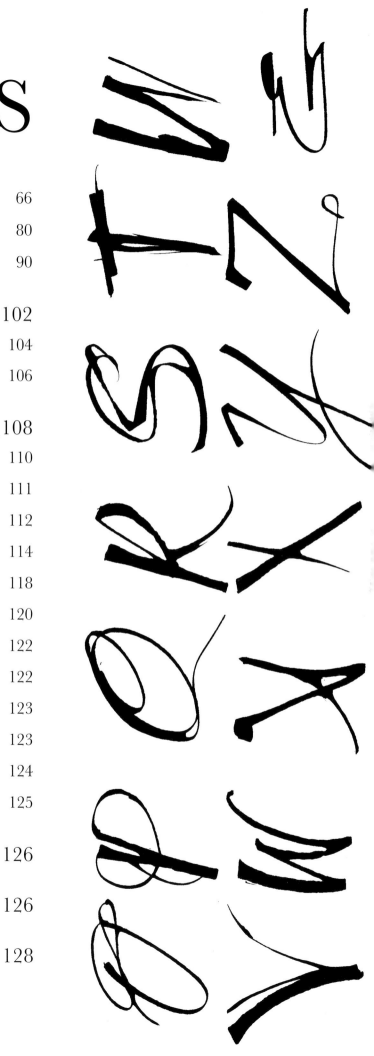

Some Words from the Author

MY STORY

I love letters and have always taken pride in my handwriting, but it wasn't until 1996 that I took my first calligraphy class. I was looking for something to do since my boys were getting older; I had tried teaching myself calligraphy but just couldn't get it on my own. I thought calligraphy would be a good addition to the cards that I was making with rubber stamps. Little did I know that signing up for that one calligraphy class would take me down a new life path, one that has brought unexpected, wonderful changes and led me to find my passion and finally realize what I want to do when I grow up!

After taking that one class, I spent six years studying the alphabet and learning calligraphy, art, and artistic techniques to enhance lettering. It was an amazing time, and I met wonderful people and made great friends. I took workshops with wonderful teachers, went to calligraphic conferences, and generally had a great time learning and playing with the letters. I call this time in my life The Six Year Journey. I am in the ninth year now, and the journey is still going strong.

One important thing a teacher told me was to do the very best I can at that moment - not to worry about what I did last time or what I will do next time, but to attempt to do my very best each time I pick up the pen, just at that moment. It just makes sense to enjoy where you are and do your best. As you learn, your work will improve and change.

USING LETTERS

Through my love of lettering, I am involved with the written word and I have a voice. I don't always know what I want to say, but I love the fact that when I do have something to say I can say it artistically. Calligraphy gives me the means to express myself, to speak my piece.

What will you do with your newfound skills? You might use your calligraphy to speak your piece or to bring something special to someone else. You can make little treats in calligraphy. Everyone loves their name when it's prettily written. Create tags for gifts and signs to welcome people home, to cheer them up, and to tell them you love them.

Letters can also add another dimension to your artwork, expressing those wonderful nuggets of truth you want to pass on and thoughts you want to encourage in other people. At the very least, they can make the world a less confusing place by clearly labeling an object. Letters are wonderful little symbols that are recognizable to everyone. They affect everyone - the order you put them in and where you leave the spaces can elicit different emotions. I hope this book will encourage you to have fun with letters.

I don't claim to have come up with every idea in this book - it's a compilation of the knowledge I gained along the way as I took classes, learned, watched, listened, and tried. I've included what I found to be the best tips and techniques. They are ones that stuck with me, work for me, and make me enjoy lettering. They make it easy to tackle, and make me want to keep doing it. I hope this information will help you or inspire you to enjoy the art of beautiful writing.

I like to think of this book as a step between formal calligraphy and modern decorative lettering. I hope you will learn the basics so you will have the strength of knowledge. Enjoy the process, and have a good journey, whether you want to whip up something quick or sit late into the night being meticulous.

THANK YOU

I am reminded that enjoyment of what you do is often determined by whom you do it with - the people. I'd like to thank all of my calligraphy friends, teachers, students, and especially the Wednesday Ladies, for being on this journey with me. My calligraphy buddies are my second family. I want to thank them for coming to my aid in writing this book, for their willingness to let me use their precious artwork, and for their sound advice.

Marci Donley

Pictured opposite page: "My Mini Autobiography" by Marci Donley. Done with a variety of tools and techniques on watercolor paper.

Calligraphic Glossary

Ascender - The part of a lowercase letter, for example, "k," "d," or "b," that extends above the body of the letter. A letter with an ascender.

Baseline - The line that uppercase or lowercase letters sit upon.

Black letters - Letters from the Middle Ages (1000-1500 C.E.) that were spaced closely together and created a dark-looking body of writing. Sometimes referred to as **Gothic**. Some forms are Gothic Textura, Fraktur, and Schwabacher.

Bone folder - A tool used in bookbinding and paper arts to fold, score, and tear paper with a pointed shape, made of white plastic or bone, usually about 6" long, 3/4" wide, and 1/16" thick.

Bowl - In lettering, this usually refers to the round shapes of letters such as "B," "P," and "R."

Chisel point - A nib that is broad side to side and very narrow top to bottom that makes thick and thin marks on the page when you are writing letters. The angle of the nib to the horizontal line determines where the thicks and thins are created.

Counter - The inside space of letters; the white space created by a black letter.

Descender - The tail part of a letter, for example, on a "y" or "g," that extends below the baseline of other letters. A letter with a descender.

Ductus - The stroke sequence or the method of constructing a letter.

Exemplar - The example sheet of an ideal style of writing that you can try to emulate or imitate; a page with an example alphabet.

Extender - The part of a lowercase letter such as "p" or "h" that projects above or below the body of the letter.

Flourish - An embellishment added to letters or an independent decoration used to enhance a piece of writing. They usually take the form of an oval, a figure eight, or a circle or are a combination thereof.

Gouache - A watercolor medium that is opaque (not transparent) with gum Arabic as the binder. This is achieved by a higher concentration of pigment or by using chalk-type fillers. Gouache can be used as a transparent medium by thinning with water. The advantage of gouache over watercolor is that you can write on dark papers and the color of the paper won't influence the color of the gouache.

Hand - One way to refer to a style of writing or an alphabet. (Some call this the **letterform**.)

Letterform - A style of handwritten letters or one letter shape.

Majuscule - A form of capital letter or uppercase form of letters in handwriting or type.

Minuscule - A form of lowercase letters, whether in handwriting or type.

Monoline - Any line created with a tool that makes a mark of consistent thickness; usually refers to a round-tip nib or pointed pen that creates no thicks and thins.

Nib - The tool used to write letters. It is inserted into a **pen holder** and dipped in ink to form the letters. Some nibs fit on the end of a fountain pen and are fed from a bladder or cartridge.

Nib width - The measurement used to determine the ratio between the thickness of a stem stroke and the height of a letter.

Pen angle - The angle at which the nib is held to the horizontal line to create a stroke width appropriate to the style of the letterform.

Pen holder - The handle that holds a nib. Together, the pen holder and the nib are a pen. The pen holder may be called a **nib holder**.

Pen width - Another term for nib width. See "nib width."

Sans serif - Without a serif.

FRIENDS...

To know someone here or there with whom you feel there is an understanding in spite of distances or thoughts unexpressed that can make of this EARTH A GARDEN.

Goethe

Serif - The entrance and exit strokes to a letter. They can be a hairline, slab, and beak; they can be sharp, or rounded. The term is used for both handwritten letters and type.

Slant - The position of the letters.

Waistline - The line between the ascender and the baseline. The letters "i," "x," and "s" touch the waistline and the baseline.

Watercolor - Pigment used for painting with gum Arabic as a binder. Water soluble, it can be used to create transparent color on paper. Usually best for white or light paper.

Weight - The thickness of a stroke in hand lettering. Some letterforms have a heavier weight (darkness) than others. Each form has a specific "color."

X-height - The height of a lowercase "x" in handwritten letters; the space between the waist and baseline. X-height is a measure of the height of the main body of all lowercase letters in a letterform. The term is also used for type.

This page: Calligraphy by Molly Gaylor. Lettered in Italic Alphabet using steel nibs. Walnut ink was used to do the lettering.

11

Tools of the Trade

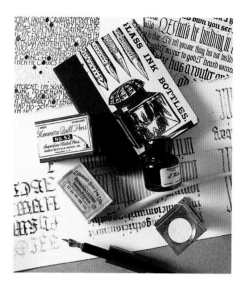

As with every art form, tools make the job possible. In calligraphy, they are writing instruments and fluids, including steel nibs, brushes, cartridge pens, markers, roller pens, paints, ink, paper, and related supplies. Knowing about tools and learning now to use them properly will help you create beautiful projects, use your time efficiently, and make your tools work for you.

Here's my advice. Get in the habit of using the best tools - your work will be easier and you will have better results quicker. Why learn something with an unsuitable tool and then have to re-learn it with one that works? Be aware that a tool will do a certain job perfectly, but for another task it might not do the trick. I'll try to point that out from time to time why you would pick one tool over another for certain applications.

Of course, you will **want** to own everything you see, hear about, or have the opportunity to try, but you don't **need** everything. Some tools are necessities and others can easily be substituted. Purchase your supplies one step at a time with an eye to the next level. As you practice and experience the tools, you will learn which ones work for you. Later, as you acquire skills, you will discover new tools for your new skills.

Left: Lettering done by Marci Donley with ruling pen using gouache.

12

TOOLS

stir stick

parallel pen

marker

small brush pen

automatic

colored pencil

BRUSH

micro uniball

chisel tip

RULING PEN

pointed pen

dimention

Magic colored pencil

fountain pen

monoline

Writing Instruments

Formal Tools

Once people wrote with quills and reeds, and their inks were made from plants and mineral elements. We are lucky. Today's tools are luxurious by comparison and easy to obtain. We don't have to make our tools every day. With the Internet, we can access nearly anything, old or new, for a price.

When you sit down by candlelight and write with a hand-cut quill on vellum you sanded by hand, you can connect with the scribes of the past who wrote and illustrated ancient manuscripts and bibles. There is pleasure in using old tools, but we also have tools that are just as efficient, if not as romantic.

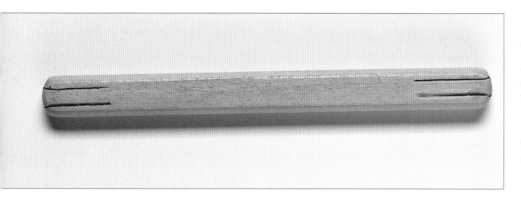

A six-sided pen holder. A good pen holder to start with is a wooden six-sided pen holder that holds a nib in each end. The shape makes it easier to maintain a constant angle by keeping it from rolling around in your fingers. Having a nib in each end allows you to work in more than one size or color.

■ PEN HOLDERS

A pen holder should hold the nib steady, and it should be easy to insert and remove nibs from the holder. Pen holders are available in many sizes, shapes, and colors. You will need a pen holder that feels comfortable in your hand.

There are specialty pen holders for beginners, two-sided pen holders, and wider grip pen holders for sufferers of carpal tunnel and arthritis. Oblique pen holders are for pointed pen hands that are written at more of a slant.

■ HOW MANY PEN HOLDERS?

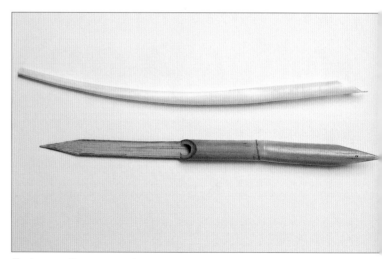

Turkey quill pen, reed pen

- At the very least, you will want to have two pen holders so you can work with nibs of two sizes or in two colors without switching back and forth. Another way to work with two nibs is to use a double-sided pen holder with a nib in each end.
- I like having a dedicated pen holder for each of my nibs so I don't have to clean and change nibs as I work. This is a bit of an investment, but it works for me.

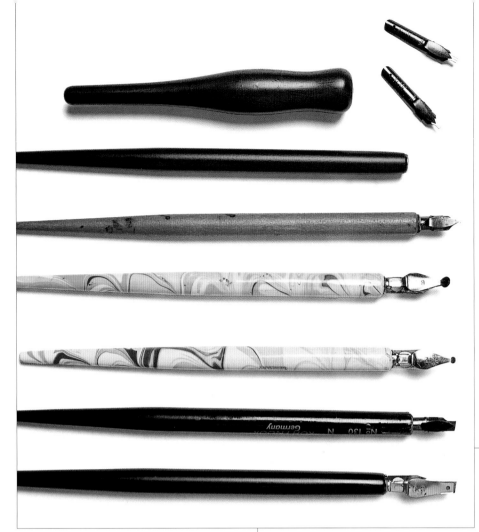

Calligraphy by Patti Peterson

Pictured below, top to bottom: Two nibs, chubby handled oblique pen holder, two crow quill pens with writing nibs, two oblique holders with pointed pen nibs, and a Copperplate nib in a clear orange pen holder.

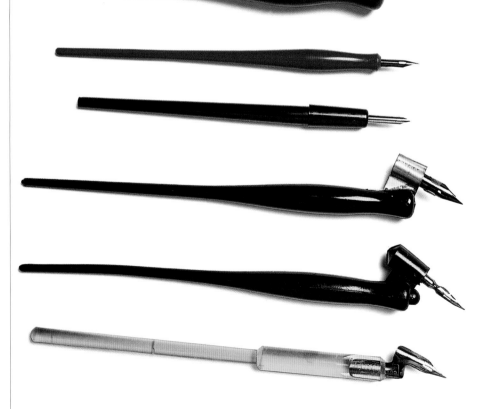

Pictured above, top to bottom: Two steel nibs, wide-handled pen holder, wooden pen holder, pen holder with broad edge nib, pen holder with monoline nib, pen holder with monoline nib, pen holder with broad edge nib, pen holder with broad edge nib.

Formal Tools, continued

■ NIBS

Nothing compares to the look of something written with a steel nib dip pen. They are unmatched in quality for crispness and beauty. Calligraphers use steel nibs for writing by dipping them into ink or paint or feeding them with a brush. Nibs can be **chisel tip**, **monoline**, or **pointed**.

Chisel tip nibs look squared off. They are also called broad edge nibs. Chisel tip nibs are used to form Italic, Uncial, and Gothic, among others. Their thicks and thins are determined by the size of the nib, the angle of the nib on the paper, and the direction of the stroke.

Monoline nibs have what looks like a little round pancake at the end of the nib. These nibs give an even line width in any direction. Ballpoint pens, roller pens, or fine-tip markers are all monoline.

Pointed nibs are used for script-like hands, such as Copperplate, Spenserian, and their variations. Their thicks and thins are determined by the pressure you exert and release. Generally, when writing with a pointed nib, you use an oblique pen holder to achieve the extreme slant without crippling your hand. You can also use pointed nibs in straight holders for drawing, fine details, and tiny writing.

There are many types of steel nibs to choose from. Each comes in a variety of sizes. Different nibs suit different people, depending on their touch and writing style. Some nibs are nicely flexible; others are more rigid. Some have a detachable reservoir. The different traits make some nibs more appealing and more useful for certain applications. I would recommend that you start with a large (5mm) chisel tip nib and a large monoline nib. You can add to your collection of nibs as you learn new hands or work on different types of papers.

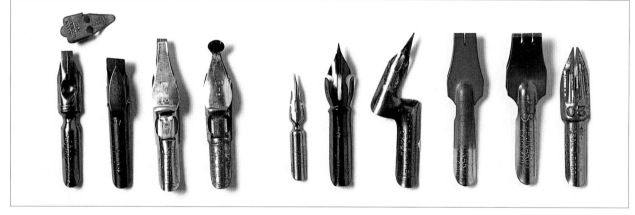

Pictured left to right: Three styles of chisel tip (broad edge) nibs, a large monoline nib, three styles of pointed nibs, two poster nibs, and a scroll nib.

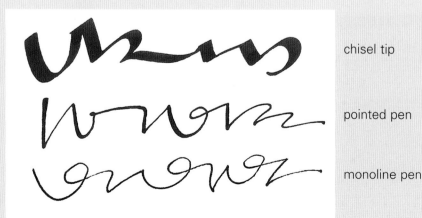

chisel tip

pointed pen

monoline pen

TIP: *I label my pens by writing the nib size on a small piece of paper that I tape to the pen holder. (Nibs are marked with the size but because I need a magnifying glass to see the notations, marking the pens saves time.)*

■ BRUSHES

Brushes can be used to do calligraphy. Brushes come in broad-edge and pointed varieties. Sign painters use one type of brush for letters and another (called a dagger brush) for pin striping. Both have long bristles; a dagger brush trails off to about two hairs.

Different types of brushes are made for use with different mediums. Learn before you buy so you will have the best tool for your job and it won't get ruined by being used with the wrong medium or cleaned improperly.

It's a good idea to experiment with a variety of brushes to find the ones that suit you best. Brushes vary in size and quality; sometimes a high-quality brush is necessary, but often, any brush of reasonable quality will get the job done. Always buy the best brush you can afford (sable brushes are the highest quality). Cared for properly, a good brush will last a long time and you won't have to replace it.

There are brushes that are meant to be used a few times and then tossed. I'm not as concerned about the quality of a brush I plan to use for a mixing brush or for painting a background. Some brushes are made to do a job for a limited time - they get used up and are priced accordingly. It's good to know the difference.

Pictured left to right: Various brushes - two round tips, a long-haired sign painter's brush, and three shorter chisel brushes. All are good for lettering.

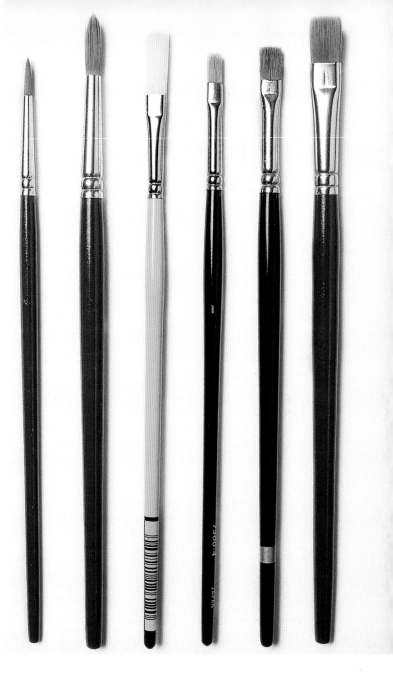

17

Less Formal Writing Instruments

■ FOUNTAIN PENS

For those who don't like to experiment with formal tools and want to make letters a little quicker with less fuss, fountain pens with cartridges are the best of both worlds. They have a nice steel tip and a constant flow of ink. You won't have the same quality of line you get with a steel nib dip pen, but it's close. I love to write with fountain pens - they make you and what you write seem important.

There are many kinds of pens with cartridges in different nib sizes and styles. They vary in price and quality, and all are pretty good. Some are close in quality to dip pens and have cartridges that can be re-filled with the ink, paint, or other writing fluid of your choice. I recommend practicing with a large-size broad nib pen. I think it reinforces your skills to start big and work down to a smaller size.

I try to get a barrel and cap for each of my fountain pen nibs because I like to have all my pens available to use at the same time. Sometimes that means hunting down a manufacturer and getting extra parts. I find it easier than changing nibs and cartridges all the time.

■ BRUSH PENS

Brushes are also available as cartridge pens. I like them better than working with a brush and ink or paint. There are some very nice small pocket-size brush pens as well as an assortment of larger brushes.

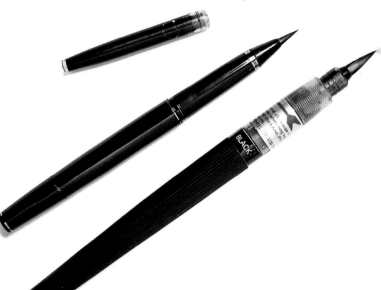

Pictured above: Two brush pens. Both use cartridges.

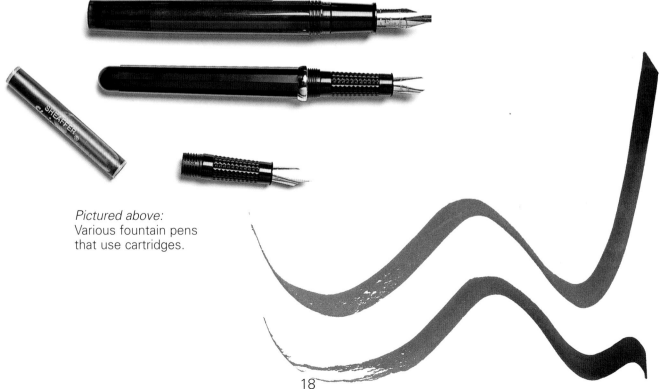

Pictured opposite page: Words done with brush pens.

Pictured above: Various fountain pens that use cartridges.

18

Explore!

The quick brown fox jumped over the lazy dog.

Soccer

Fall

Spring

Season's Greetings

Our Trip

Memories

PATTI PETERSON 2005

Informal Writing Instruments

◼ MARKERS

If you want to create something right now, quickly, with lots of bang, perhaps you just want a marker. Markers are great tools. They come in many colors, aren't too expensive, are easy to maintain, and have a variety of sizes of tips. And they are loads of fun to use.

Markers are available in chisel, monoline, scroll, and brush tips. Many markers have two ends so you can make two different marks with each.

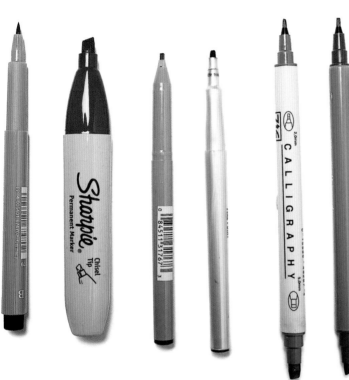

Pictured left to right: Various markers - green brush marker, red large chisel tip, two small chisel tips, two double-ended chisel tip markers.

TIPS

- When you use chisel tip markers you sacrifice some quality of writing. The tips of markers are not as sharp as steel, so you generally get a thicker line.
- Not all markers are equal. Consider the quality of the tip. You want markers that hold a sharp edge and maintain a good flow of color for a long time. It is harder to find good quality markers in smaller sizes.
- Start with a 5mm or 3.5mm marker.

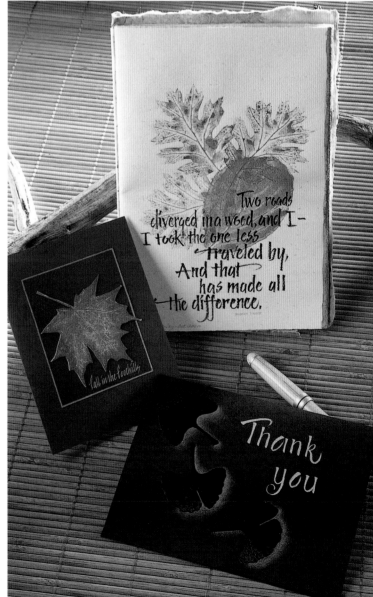

Pictured right, from top to bottom:
- Poem lettered by Marci Donley in Italic Alphabet done with brush markers. Poem is decorated with leaf prints.
- Greeting card by Patti Peterson. Lettering is Italic variation using gold ink. A leaf cutout decorates card.
- Thank you card by Patti Peterson. The italic lettering is done with a brush.

20

Experimental & Specialty Writing Instruments

Poster pens are dipping pens that come in a variety of large sizes and nib types that are used for larger writing. One type of poster pen is called the **automatic pen**. An automatic pen is not what the name implies - it is in no way automatic. Automatic pens have a nib that is uniquely folded. They are used to produce particular effects.

A **ruling pen** is a drafting tool for making lines of even thickness. Calligraphers have adopted the ruling pen for writing (particularly for creating jagged edges and/or an imperfect look). Ruling pens are great for giving your work expression and adding to the effect of the words.

There are an array of ruling pens and folded pens available; find them at a calligraphy supplier.

Above: Molly Gaylor created this artist book using paste paper and wrote with steel nibs and gouache.

Two poster pens. These particular ones are automatic pens. The one with the points on the nib is called a music pen. It can be used to create the musical staff seen on sheet music.

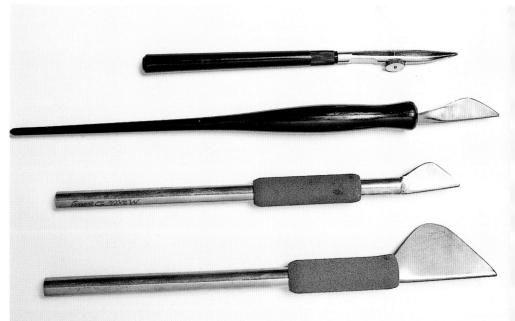

Pictured top to bottom: Ruling pen, Mitchell folded pen, Jim Chin's Moth and Butterfly pens.

WRITING FLUIDS

Inks

There are many types of inks, all with slightly different consistencies. Some are thicker than others. Some dry more slowly. Some containers have a built-in dropper. It's a good idea to try different inks and see what you like.

Start with good black ink - many varieties are available in bottles. Next introduce colored ink. There are acrylic inks that won't smear if they get wet. Try some pearlescent ink.

You can produce interesting work with walnut ink. Walnut ink is purchased dry (its granules look like coffee grounds) and you add water to reconstitute it.

To explore the Zen of writing, try some stick ink. Good stick ink is a fine quality ink and the results are well worth the time. The process of grinding the ink and using traditional tools makes for a nice experience.

Inks pictured clockwise from top right: Bottled ink, acrylic ink, Japanese stick ink, walnut ink crystals.

Pictured below: Bookmark by Joan Hawks. Alphabets are Roman variation and thin Monoline

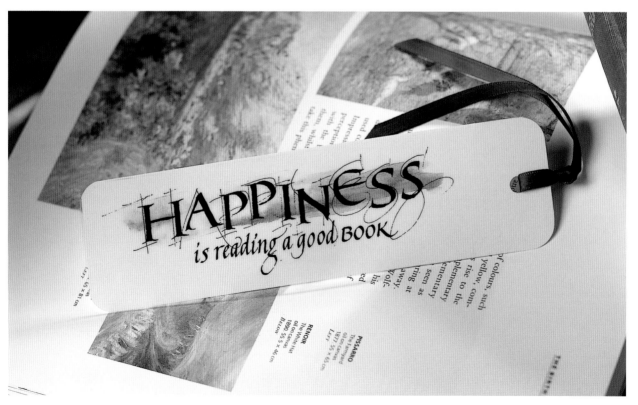

Paints

I prefer **gouache** and **watercolor** to ink for writing because I think they produce a better quality of writing, and there is a wider color palette available. Both gouache and watercolor are water-based paints that come in tubes. Watercolors also are available in little pans or pots of color in a palette box (just like the watercolors you may have used in school). The biggest difference between watercolor and gouache is the opacity and density of color - gouache is more opaque and dense. They vary in quality; buy the best you can afford.

Acrylic paints are also used for writing. They have the advantage of being waterproof when dry but are just a bit more trouble to work with and clean up after because they thicken and dry up quicker on the nib.

You will need mixing dishes or small containers with lids to mix and store your paints. If you mix colors, remember to stay within the same medium for best results - don't mix gouache and watercolor, for example.

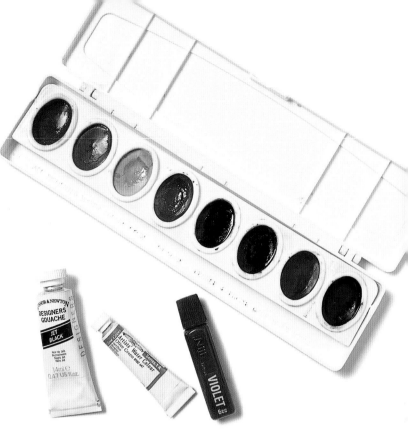

Pictured left to right: Gouache, two types of tube watercolors, palette box of watercolors.

Pictured below: Calligraphy by Molly Gaylor, Italic alphabet using steel nibs and gouache on paste paper background.

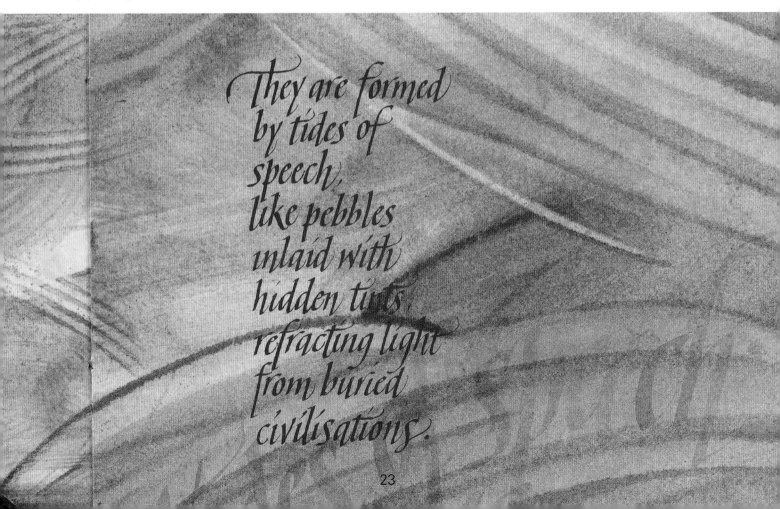

They are formed by tides of speech, like pebbles inlaid with hidden tints, refracting light from buried civilisations.

MEASURING & LINING TOOLS

You also need measuring and lining tools to help you create beautiful lines of letters. I recommend you start out by working on **graph paper** and use a **graph ruler** for lining. This is the easiest lining technique I know and the most effective way to learn.

Here are other tools and their uses:

• A **T-square** is a good tool for lining - Measure with a ruler and make tick marks on one side of your paper, then use a t-square to line across the page.

• A **clear ruler with a metal edge** is good for cutting against - you can see the edge you are creating.

• A **metal ruler with cork back** is good for both lining and cutting. The backing keeps it from slipping.

• A **protractor** will help you to determine the pen angle. Place the protractor on a horizontal writing line, mark the starting point (the spot you are measuring from), and place a tick mark at the correct degree mark. Then move the protractor and draw a line to connect the marks - that's your slant line. The slant line indicates the proper writing slope. Draw more slant lines, using the first line as a guide.

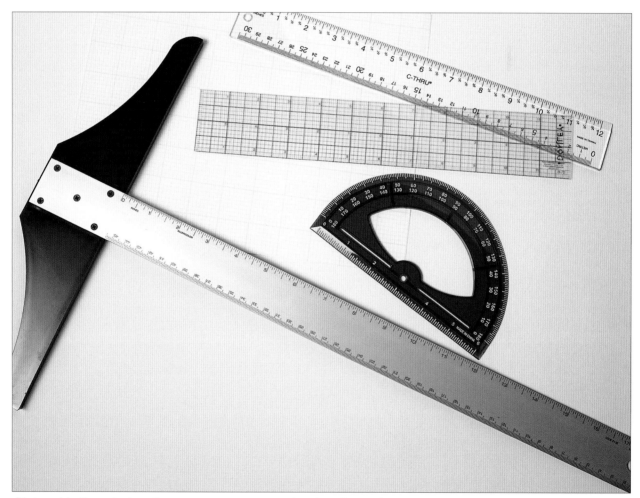

Pictured bottom to top: T-square, protractor, graph ruler, clear ruler.

Pictured right: Envelopes lettered by Xandra Zamora. Lettering done with copperplate pointed pen variation.

Mr. & Mrs. Charles Lamb
132 Peach Tree Lane
Atlanta, Georgia
4 5 6 5 4

Mr. and Mrs. Nathan Shepherd
3201 Main Street
Albuquerque
New Mexico
8 7 1 0 1

Mr. & Mrs. Logan Smith
381 Charles Avenue
Nashville, Tennessee
4 5 6 7 8

PAPERS

Choosing the paper is the starting place of a project. The quality of the paper you use makes a statement about your work. When you choose paper for a project, it's also important to consider what the item will be used for. Is the weight of the paper appropriate? Can you fold it (if you need to)? Will it stand up (if you want it to)? Can it be handled a lot?

Some papers come in tablets and some comes by the sheet in various sizes. I recommend you start with **graph paper.** The important connections that you will make by seeing the boxes on the paper and forming your letters with those measurements in mind will help you learn. Calligraphy should be accurate, and the attention to detail and consistency make writing beautiful and even. Graph paper helps you attain that consistency. The blue printing on graph paper will not copy on a copier so it is excellent for work that will be reproduced.

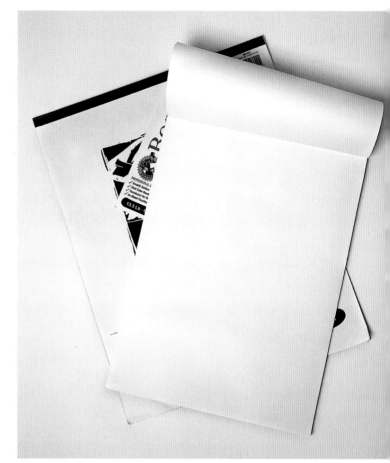

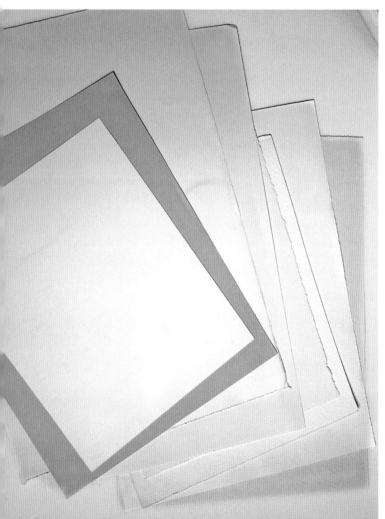

Pictured above: Papers that come in tablets include graph paper, tracing paper, and layout or sketch paper.

Pictured at left: A variety of writing papers available in sheets, including diploma parchment and watercolor papers.

Generally it is good to have a pad of layout or sketch paper, tracing paper, and some good writing paper. My favorite all-purpose papers for writing are sturdy papers with a good finish, such as diploma parchment and text papers. Watercolor paper is available with a smooth surface (hot press) or a rough texture (cold press) in weights from 90 lb. to 360 lb. The 90 lb. hot press watercolor paper is a good choice for writing and is available at most art supply stores.

It is nice to have some fancy papers, specialty papers, and decorative papers. It might surprise you to learn you can write on papers that are very porous or delicate. Test your paper with ink or gouache to see if it runs; if it does, spray the paper with a fixative to make a writable surface.

Today's vellums, the translucent papers that are used widely in cards, scrapbooks, and other paper crafts, are made from wood pulp, but the vellum that was used for old manuscripts is actually made from calfskin.

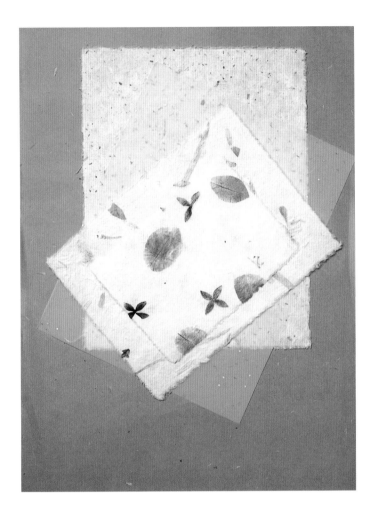

Pictured above: A variety of types of good writing papers of various weights, including card paper and cover weight paper.

Pictured left: A variety of decorative and hand-made papers, including paper with pressed dried botanicals, vellum, lightweight paper, and hand-made paper.

PAPER TIPS:

- *If you love paper and find yourself collecting lots of it (and if you have the space), invest in paper drawers to store your paper. Jump-start your projects by shopping in your paper drawer.*

- *Resist the urge to stockpile papers - use them! Don't get into believing there are papers so beautiful and precious that no project could possibly be special enough.*

- *Be sure to buy extra paper for a particular project so you will have enough for practice and mistakes. Knowing you have extra paper makes you more relaxed. If you don't use the paper with this project, you'll have it for the next, or for practice.*

- *Practice on good paper. Don't let your fear of messing up the paper keep you from writing. You never know when your first try at something will turn out to be the best - you don't want that to be on lined yellow legal pad paper.*

- *Paper is meant to be used. Don't let it scare you. Use it. Once I was in a class when a teacher ripped up a beautiful sheet of paper after extolling its virtues and telling us how expensive it was. She then gave us each a little piece of the paper as a reminder that no paper is too good to use.*

TOOL BOX BASICS

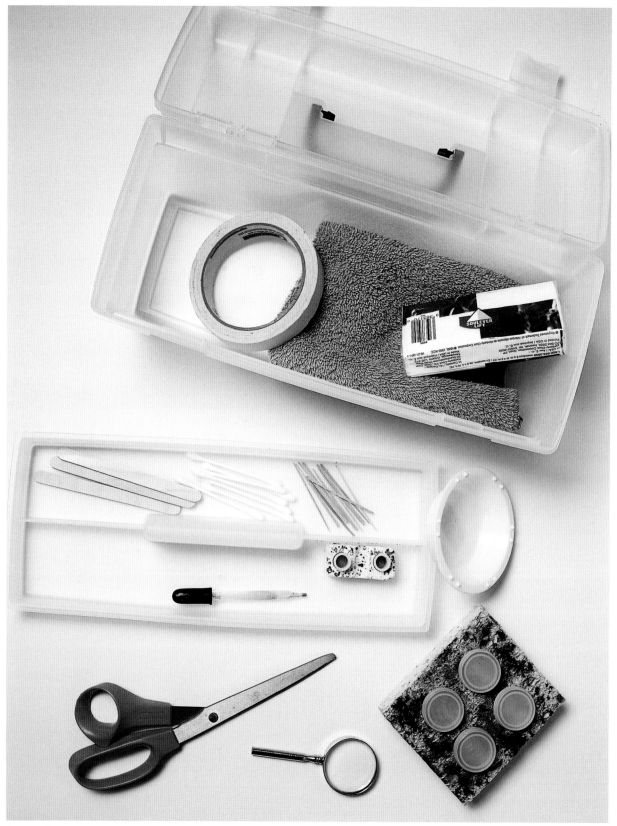

Items for your tool box.

Always keep these items handy when you work - they are the tools that support your new skill, and they will make your task easier. (You may already have some of them if you are involved with other artistic endeavors.) Put them all in a box and know that they are your calligraphy tools. Add to your toolbox as you go.

We've already discussed writing instruments, ink and paint, and measuring tools. In addition, these are the items you need to have:

Non-reproducible blue pencil and **sharpener**

Mechanical or drafting pencil with HB lead and **sharpener**

Low tack masking tape, to secure your work

Scissors, for cutting

Magnifying glass, for seeing the markings on the nibs and for looking closely when making corrections

Small containers, for dipping, mixing, and storing paints and inks

Rags, for wiping. Choose an absorbent cloth that won't leave fuzz behind.

Tissues, for wiping up small spills and for cleaning nibs

Cotton swabs, for picking up paint drips

Toothpicks, for removing mistakes

Craft sticks, fox mixing paint

Water dish - You need a small container that will hold about 3/4" of water for swishing your nib to clean it.

Old toothbrush, for cleaning nibs

Glue stick, for layering papers

Cutting mat, to use with a craft knife

Craft knife with #11 and #16 blades for cutting paper and fixing mistakes

Burnisher, for smoothing the paper surface after correcting a mistake

Bone folder, for scoring and folding paper

White eraser, for removing lines

Eyedropper, for transferring ink

Sponge, to dab pen onto before you begin lettering

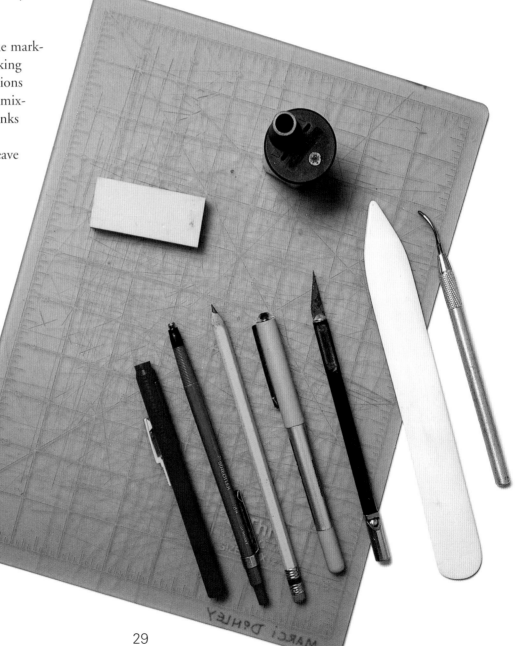

Underneath it all: A cutting mat

At the top: White eraser, drafting pencil sharpener

Below, left to right: Stick eraser, drafting pencil, non-reproducible blue pencil, black pen, craft knife, bone folder, burnisher

CREATIVE LETTERING SUPPLIES

For times when you want to get creative or whip up a quick card or tag, keep these items handy - near your work area or near your tool box. You are much more likely to use them if you don't have to go looking for them. Don't be limited by this list; let it inspire you to try new things.

Creative Supplies

Colored pencils
Watercolor pencils
Dimensional paint
Foam brushes
Round sponge-on-a-stick
 applicators
Monoline markers - various
 sizes, weights, and colors
Brush markers - various sizes,
 weights, and colors
Gel pens
Water brushes
Gold and silver pens
Novelty pens, like a shingle pen
 or folded metal pen (See the
 photo for examples.)
Stir sticks
Embossing powder
Charms, beads, etc. (for
 making collages)

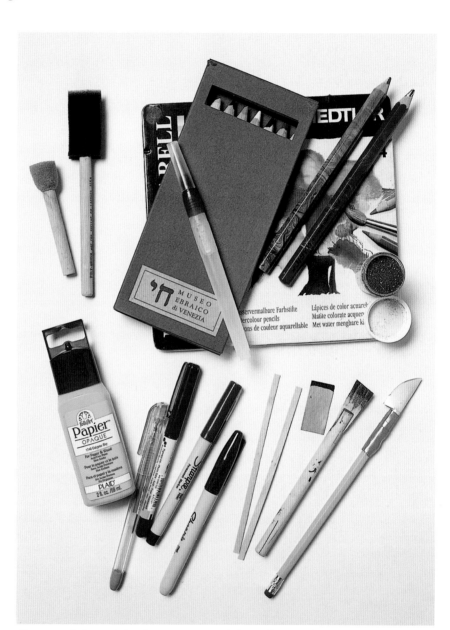

Top row, left to right: Sponge-on-a-stick applicator, foam brush, water-color brush, colored pencils, watercolor pencils, embossing powder
Bottom row, left to right: Dimensional paint, gel pen, fine point markers, stir sticks, wooden doll house shingle, a shingle made into a pen, folded metal pen made from a can

Pictured opposite page: Calligraphy by DeAnn Singh. Uses Gothic alphabet done with acrylic paint on canvas. The canvas was sewn to a pillow cover and edges were covered with trim.

La piu divina
bella poesia
quella amico che
c'insegna a
amare

The most divine
of poems is the friend
which teaches us to LOVE

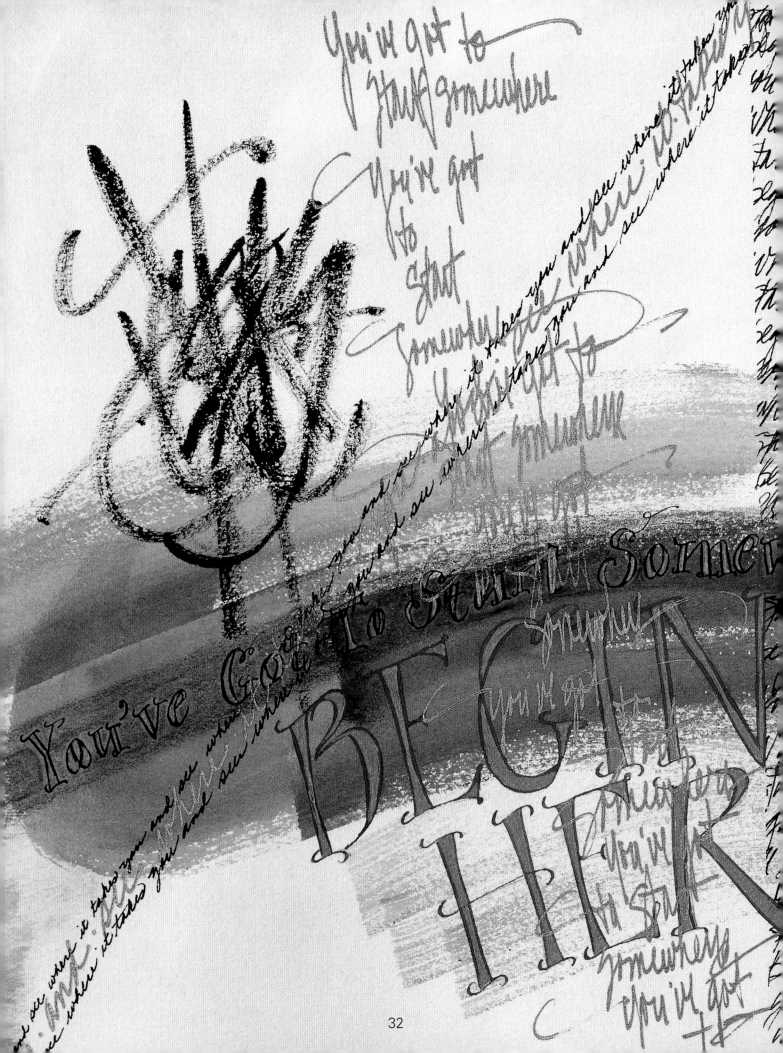

You've got to
Start somewhere
You've got
to
Start
Somewhere

You've Got to Start Somewhere

BEGIN HERE

Getting Started

I like to think of the letters as little pieces of a painting that are formed by a technique and a sequence. Just as you would paint a flower step by step, you also form letters step by step. Lettering is not the same as writing a grocery list - if you understand this, you will be less frustrated if your letters don't come out as you want them to the first time. For best results, you must practice drawing or painting your letters just as you practice drawing or painting a flower.

Every calligrapher has his or her own way to begin a project. My way is to clean my studio, to put away what's left from my previous project before I tackle a new one. This organizing process helps me get into the mood for the new project, and while I organize I think and design in my mind. As I take out the supplies I will be using for the current project, I continue to design in my mind. By the time I have everything out I am ready to write.

Of course, this process can be mistaken for procrastination, and if it goes on too long, that's what it is. Eventually, there is a point when you need to jump into a project, ready or not. When that time comes, just sit down and write!

SETTING UP YOUR WORKSPACE

Nearby, you'll want to have a rag, tissues, a small shallow container with some water and an eyedropper, additional water, small containers to hold your colors, and a sponge or scratch paper to dab your pen on before you put it to the project paper, plus paint or ink, a pen, and a mixing brush.

Place your tools on the side you prefer to dip your pen. (If you are right handed, you'll probably want to dip on the right side; if you are working with gouache and loading the nib with a brush, you may want your setup on the left side. Play around with both and see what is most comfortable or works best in your space. Set your writing tools on an old dishtowel or piece of mat board just to protect the surface of the table and make it easier to clean. It is not a bad idea to secure the container that holds your ink or paint with tape to avoid accidental spills.

Your workstation should be comfortable, well lit, and located in a place you like to be. Ideally, you'll have a permanent spot where you can work, and once it is set up you will only need to make changes for the specific project you are working on.

Calligraphers usually work on a stationary slant board or a board that they can hold on the lap. Working on a slant board helps avoid the back and neck pain that can come from leaning over the table. It also helps the flow of the

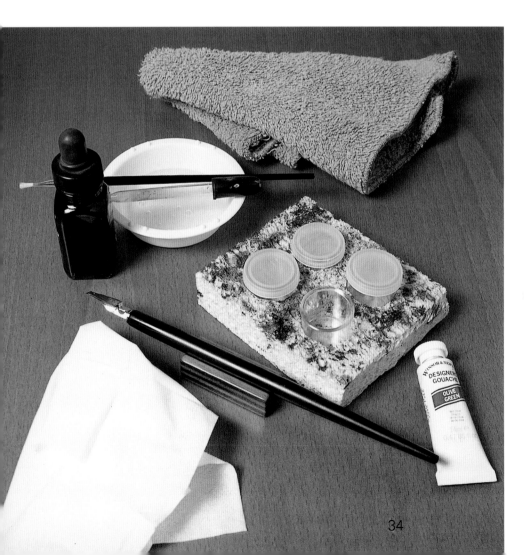

ink. On the slant board, place a few sheets of paper or a piece of craft foam or felt to act as a cushion for your writing. Next comes the project paper, and then a sheet of paper on top of that to rest your hand on as you work so the oils from your skin (or any unwanted dirt) aren't transferred to the project paper as you write on it.

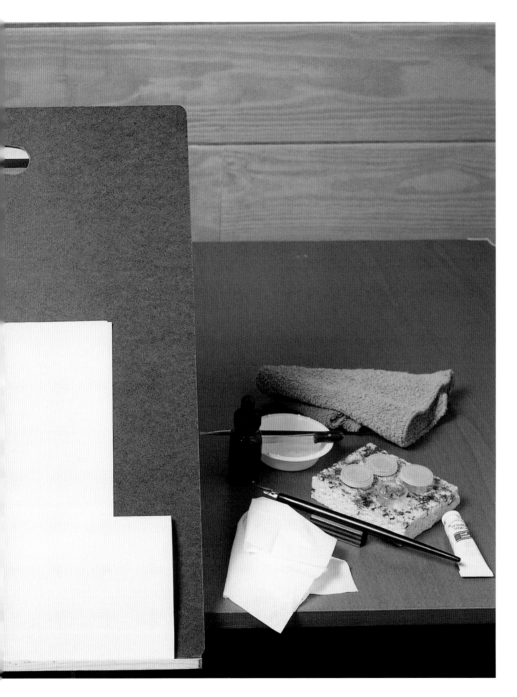

Atmosphere

When I am setting up for a specific piece I like to create the proper atmosphere. Try lighting a candle when using historical hands and imagine being an ancient scribe. Or brew yourself a cup of tea and serve it in a dainty cup when you are doing copperplate. Play music that soothes or inspires you.

Projects to Music

When I sit down to work on a specific technique or project I pick a music CD to listen to. Each time I continue work on that skill or piece I put on the same CD. After a few times of doing this I find that the music helps to trigger a great start as I quickly focus on my work.

CHOOSING THE CORRECT PEN

The pen you use determines the size and look of your writing. As discussed in the "Tools of the Trade" section, there are chisel tip, monoline, and pointed pen varieties.

The first step toward learning a calligraphic hand is to look at the exemplar. Most exemplars will have the information you need to write in that style noted on it.

Height

Every style of writing has an x-height, which is the space between the waistline and the baseline. This varies for each hand. When you look at an exemplar for a hand done with a broad edge pen, you'll see a notation of how many pen widths make up the x-height for that hand. You want the proper number of nib widths for the hand so your work will have the right proportion. If your nib is too small, your letters will get too thin and leggy and won't look strong. If your nib is too wide, your letters will look chunky and too dark.

You can choose the pen size one of two ways:

1. Determine the size you want to write and pick the pen to fit.

2. Pick the pen, then determine the size.
 Either way, you will need to measure the x-height.

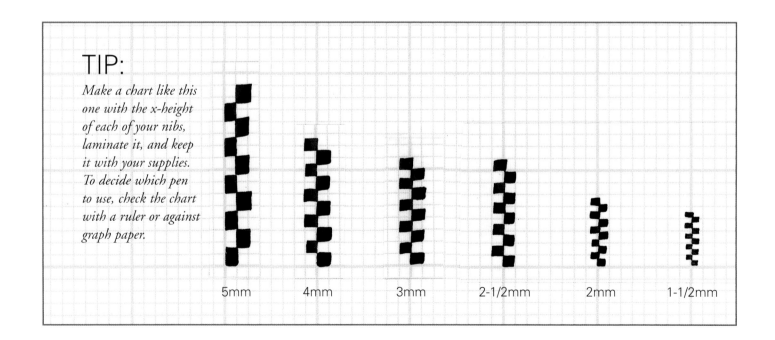

TIP:

Make a chart like this one with the x-height of each of your nibs, laminate it, and keep it with your supplies. To decide which pen to use, check the chart with a ruler or against graph paper.

5mm 4mm 3mm 2-1/2mm 2mm 1-1/2mm

HOLDING THE PEN

Pen Angle & Slant

The pen angle, which also is indicated in the exemplar for a hand, determines how you hold the tip of the pen and the slant of the hand. For instance, you hold the tip of the pen at a 45-degree angle when you write Italic and at a 30-degree angle when you write Uncial.

Use a protractor to determine the slant line by

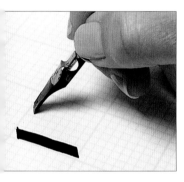

placing the protractor on a horizontal writing line. Mark the starting point (the spot you are measuring from) and place a tick mark at the correct degree mark. Then move the protractor and draw a line to connect the marks - that's your slant line. Draw more slant lines, using the first line as a guide.

BELOW: If you are using graph paper with eight boxes to the inch, the nib would go diagonally across one box for a 45-degree angle; for a 30-degree angle, it would go diagonally across two boxes side by side.

Start

Start by making some marks. Dip and get the feel of the pen with a few strokes. Don't even worry about angle at this point - just try to make a solid connection with the paper and have the ink flow through the pen evenly (not too dry or too runny). All your edges should be crisp. Keep both sides of the nib evenly on the paper.

Traditional vs. Modern: Two Views

Some people love fussing with the traditional calligraphy tools. Usually I love mixing paints and inks and pretending to be an alchemist, but sometimes I just want to get past all that and do some serious playing.

If you don't want to fuss with all the tools or if you're getting frustrated, try a cartridge fountain pen or a marker. If you thrive on all the fuss, stay with it.

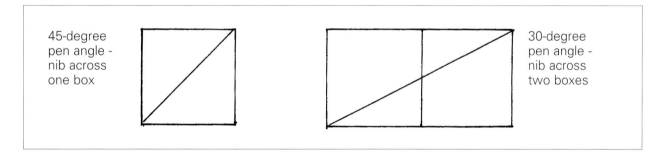

45-degree pen angle - nib across one box

30-degree pen angle - nib across two boxes

If You Are Left-Handed

Many of the best calligraphers I know are left-handed, and being left-handed shouldn't hold you back once you find the way to make letters that works best for you. Left-handed calligraphers need to find a way to write that is comfortable, a way to follow the ductus (the stroke sequence), and a way to write without cramping or smearing the work as they go.

If you are left-handed, you have had to figure out how to do many tasks; put these skills to work as you approach calligraphy. Here are some suggestions:

• **Left-handed nibs.** Buy the special left oblique nibs made for left-handers and tilt your paper a bit to the right. You can follow the ductus for the right-hander.

This works for many people.

• **The hook.** Left to their own devices, the most common way left-handers write is the hook method, coming at the letters from above and using a standard (right-handed) nib. To do this, you must alter the ductus a bit.

• **Sideways or upside down.** For the sideways approach, turn the paper 90 degrees clockwise and write from the top to the bottom of the page. For the upside down approach, follow the ductus upside down.

• **Markers.** Using a marker makes the whole process easier, especially when you're starting out.

PREPARING THE PAPER

The best quality of work is possible when you put your guidelines directly on your work. It is easy to line up your paper using graph paper and a graph ruler, and it is helpful to line in the waist and baselines and the ascenders and descenders even when you are using graph paper.

The more accurate your lines are, the better your work is. Use a mechanical or drafting pencil and HB lead for lining. Lead that is too hard scores the paper and is hard to erase, lead that is too soft can smear and get messy. Sharpen your lead often. It is important to have a sharp pencil for lines; the smaller your writing space, the more accurate the lines need to be. If the weight of the line varies or you don't keep your pencil uniformly sharp, you can affect the straightness and size of your writing.

When your work is completely dry, go back and take out the lines with a white eraser.

Another way to work with lines is to line a master and use that under your paper on a light table. Make the master in dark ink that you will be able to see through the paper on the light box. However you decide to work you will need good quality, accurate lines.

The writing space of a letterform is determined by the x-height on the exemplar or by the size you have determined you want to write, and the hand and the style usually determine the size of the ascenders and descenders. Look back to the exemplar to determine how much space to leave between the writing lines. (This is called the interlinear space.) A good general rule for determining the interlinear space is to follow the lining on the exemplars. Alternately, you can choose an interlinear space that is the distance of two x-heights between writing lines so your ascenders and descenders don't touch.

Draw straight lines

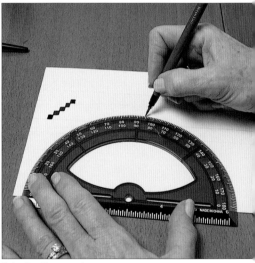

Mark diagonals

Draw remaining lines

Working on Black Paper

Problem: Pencil lines are hard to erase from black paper because erasing changes the paper. Pencil lines are also hard to see on black paper unless the lighting is perfect. Plus, you can't see through black paper to use it with a master on a light table.

Solution: Make lines lightly, using a very thin permanent black ink pen (.005) and leave them as part of the design. Make the lines only where you absolutely need them, and adjust your lighting to help you see the black lines. (I sometimes use two lights, one from each direction.)

USING A LIGHT BOX

Everyone who does calligraphy will need a light box (or its equivalent) at some point. If you use a slant board, all you really need is a piece of translucent plastic glass to fit on your slant board and a light source behind it. A low-cost solution is to use an under-cabinet light fixture (find one at home improvement stores). If you don't use a slant board, you can use a light source under any glass table or surface. And don't forget holding the paper on a window.

A light table is a great time saver. If you are going to do something lined more than once (and it is likely you will!), it is helpful to make some guidelines you can use under your paper on the light box so you don't have to keep lining paper over and over. TIP: Copy your masters on transparent sheets; the lines show through better.

When you are writing on envelopes, using guidelines keeps them all uniform and, again, cuts down your working time. You can make a master for just about any practice or project and use it under your paper with the light shining through.

You can also use your light box to trace shapes and artwork to add to your calligraphy.

Place your guideline sheet on the light box, secure your paper to the guideline sheet, and write. You won't have any guidelines to erase when you finish.

OF SEASONAL GOODS WHOSE BUSINESS WAS LOCATED ON THE BANKS OF YANAGIHARA IN THE KANDA DISTRICT. THERE HE MADE CARP BANNERS (KOI NO BORI) FOR BOY'S DAY ON MAY 5, FANS FOR THE HOT SUMMER MONTHS LEADING UP TO THE FESTIVAL OF DEAD, AND KITES. THE RESIDENT ARTIST WAS YOSHITOYO UTAGAWA, WHOSE SON, UMEMITSU, WAS EXERCISING HIS EXPERTISE ON KITES. HE ALSO HAD A FRIEND, SAKAMOTO FUSAKICHI, A DYER BY TRADE, WHO APPLIED TO PAPER THE STENCILING TECHNIQUES ORIGINALLY USED ON CLOTH. WHEREAS INDIA-INK PRINTS HAD HERETOFORE BEEN COLORED BY HAND, THIS INNOVATION ALLOWED FOR THE EFFICIENT MASS PRODUCTION OF MULTI-COLORED KITES. YOSHITOYO DREW MANY WARRIOR PICTURES.

SOON AFTER THE WAR, IN 1946, TEIZO HASHIMOTO MARRIED KIYO, TWO YEARS HIS SENIOR. SHE WORKED SO HARD ALONGSIDE HER HUSBAND THAT SHE SOON DEVELOPED CALLOUSES ON HER LEFT HAND, AND YET ALL THE WHILE SHE MANAGED TO HANDLE

Calligraphy by Jane Shibata, *Early Kites*, done in Uncial alphabet with stick ink and steel nibs. You can see the importance of accurate lining in this piece.

USING PENS

Using the Beginner Pen

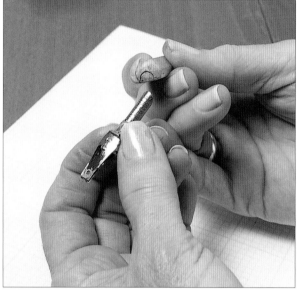

Placing a nib in the pen holder.

The pen holder and nib.

A good pen for beginners is a six-sided wooden pen holder. The six sides keep the pen stable in your hand, which is helpful when you are learning to hold the pen at a steady angle.

Filling a Pen with Ink

Put the ink in a small container that you can dip into without making a mess. This will help keep your fingers and pen holder rims clean and keep your main source of ink from drying out or getting contaminated. During this process, keep your ink bottle capped as much as possible to avoid accidents.

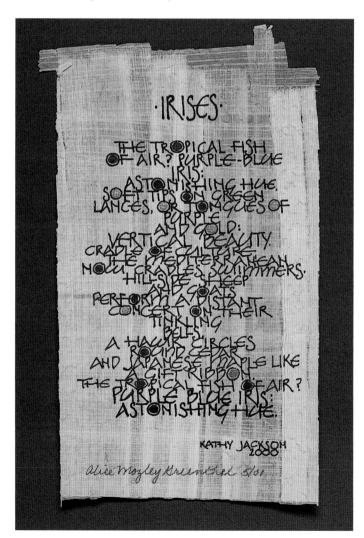

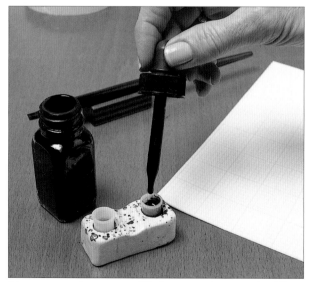

Use an eyedropper to fill the container, and refill as needed.

Pictured left: Calligraphy by Alice Greenthal. Monoline pen on papyrus.

40

Filling a pen, continued

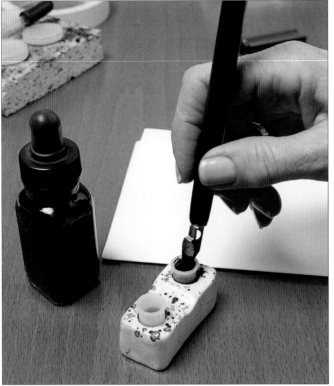

Dip your nib into the ink container, making sure the ink fills the reservoir.

PEN TIPS:

- ***Blot.*** No matter what fluid you use, blot your pen on a sponge or a rag before writing.

- **Test.** Take a little start stroke on a piece of scrap paper to make sure you have the right amount of ink or paint before you begin to write your project.

- **Let dry.** Once you have put your mark on the paper let the ink set. The fluid needs a chance to enter the fibers of the paper and dry.

- **Clean.** Clean your nib occasionally as you work to avoid buildup, and also before you put it away.

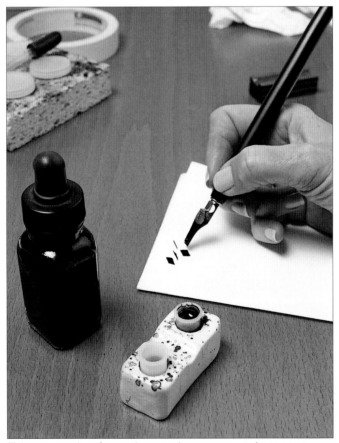

Take a couple of practice strokes on scratch paper to make sure the ink is flowing smoothly, or blot the nib on a sponge or rag.

Using Paint to Fill a Pen

If you want to work with paint, you must first thin it to a consistency that you can write with. The thinned paint should be about the consistency of cream (or ink) for best quality and ease of writing. Any tube paint should be prepared this way.

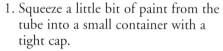

1. Squeeze a little bit of paint from the tube into a small container with a tight cap.

2. Add a little bit of distilled water. NOTE: Distilled water is purer than tap water or spring water. Use it if your piece is special and you would want it to last as long as possible. If you are doing something with a short life, the kind of water you use doesn't matter.

3. Use an inexpensive bright bristle brush to mix the paint and water.

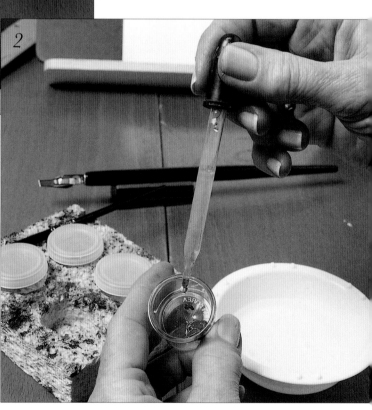

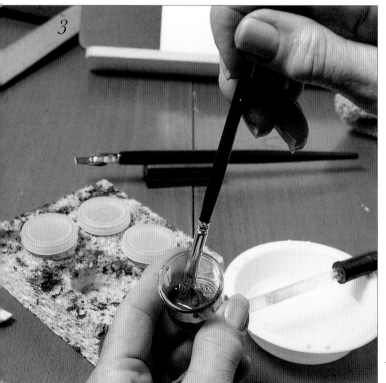

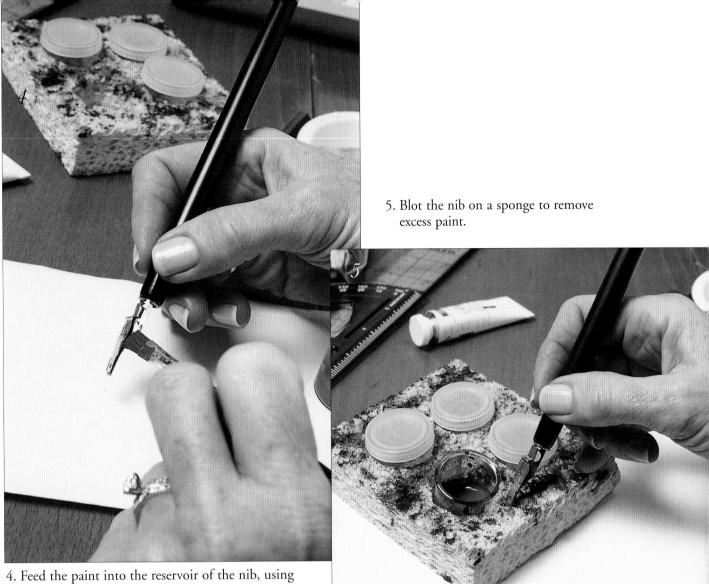

5. Blot the nib on a sponge to remove excess paint.

4. Feed the paint into the reservoir of the nib, using the brush. (The mixing brush will feed the pen and clean it as you brush the paint into the nib.)

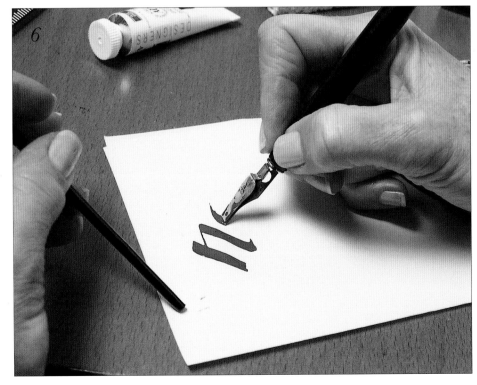

6. Write. Use the handle end of your mixing/feeding brush to hold the paper in place and to remind you to hold the end of the brush away from the paper.

CLEANING PENS

It is important to keep nibs clean and dry to avoid rust and corrosion. Some inks or paints will eat away at your nibs if you don't remove it.

Always clean your nib before you put it away, and clean it occasionally as you work to avoid buildup. If your nib gets very dirty, scrub it gently with an old toothbrush.

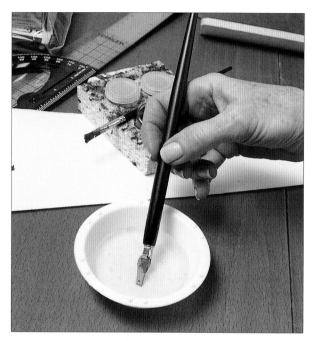

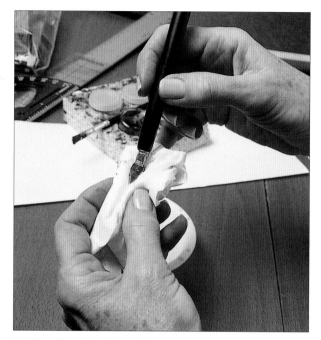

1. Put some water (about 3/4") in a shallow container. Dip your pen in the water and swish the nib to clean it. (You want only a small amount of water so you won't get the pen holder wet when you swish the nib.)

2. Blot the nib with a tissue.

I write you letters by the thousands in my thoughts

LUDWIG VAN BEETHOVEN

This page:
Calligraphy by
Carol Hicks. Lettering
is Italic variation on Mulberry
paper using gouache with steel nibs.

Opposite page:
Calligraphy by Carol
Hicks. Italic lettering
on black paper,
gouache with steel
nibs.

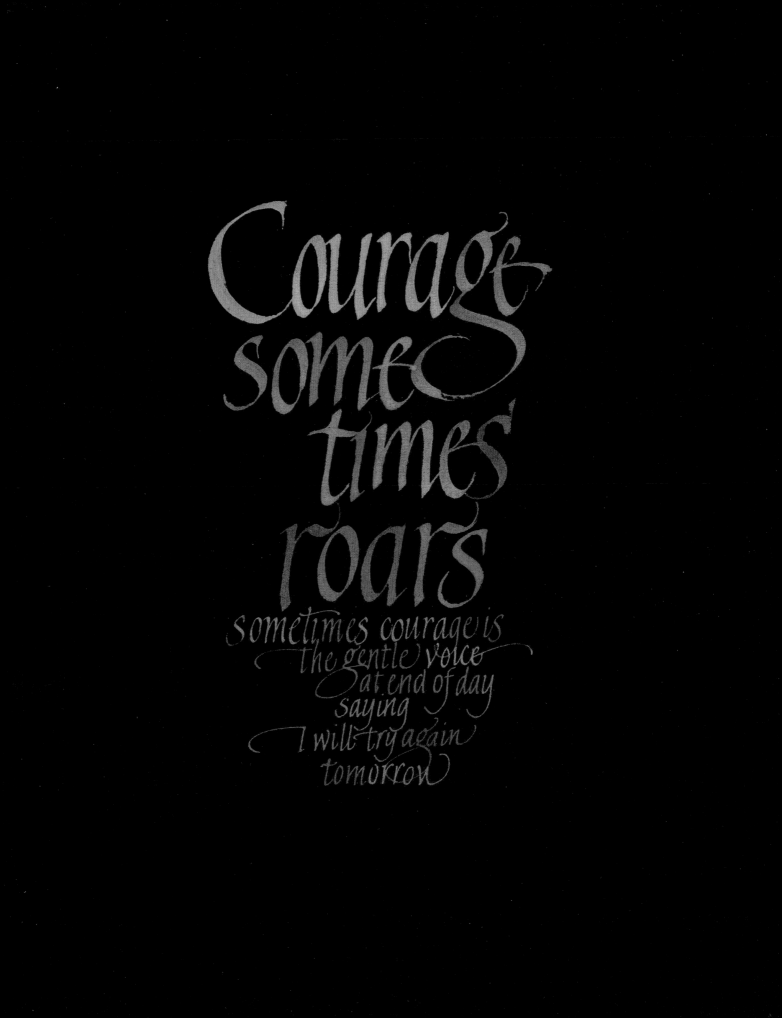

Courage
some
times
roars

sometimes courage is
the gentle voice
at end of day
saying
I will try again
tomorrow

Classic
Alphabets

The classic alphabets in this section are the basis of calligraphy today. Because each calligraphic letterform is different in its basic requirements, the presentation will vary. Embrace the key points that make each letterform distinctive.

Knowing the history of calligraphy and what is historically correct is a prerequisite to any lettering. You must know the basic forms and how they all work together to perfectly make a beautiful letter and a whole alphabet.

Think of letters as drawings, and slow down the writing process to a series of strokes that you execute carefully and purposefully that, when combined, just happen to form little drawings of letters. Concentrate and think about what you are doing, stroke by stroke, and try to do the very best you can at that moment. Once you know the rules you can determine when you might want to break them, and break them with purpose as a design choice.

The exemplars for the alphabets are written on grid paper. The nib type, pen angle, and x-height are indicated. You can count the boxes of the grid paper to keep the proportions correct as you execute the letters.

The worksheets have the letters exploded and put together, and they are printed in colors. You can see how the letters are put together where the overlaps happen, and the stroke sequence, which is known as the ductus, is also indicated.

Calligraphy by Molly Gaylor. Italic and Roman alphabets, pigment ink on vellum.

Manuscript Sur Peau de velim, actual manuscript page from a small prayer book.

HOW TO USE THIS SECTION

Part of the process of learning calligraphy is training your hand and your brain to work together. Make your practice time count - think of it as rehearsing for a performance. If you don't rehearse the correct way, the performance won't get any better.

- **Copy the worksheets.** Photocopy the practice worksheets so you can work directly on them, or photocopy the worksheet guidelines and use them on a light table under your graph paper. (This is less expensive than photocopying in color.)
- **Copy the exemplar.** Copy the exemplar and write your ductus directly on it for your practice - it will give you a good sheet to work from. Put it next to you when you are writing and refer to it each time you make a letter.
- **Follow the example.** Look at the exemplars and notice what tool was used. Use that tool and the suggested guidelines to practice. If you decide to use a different tool, follow the tips in the Essentials box.

- **Trace the letters.** Put the exemplar on your light box and place paper on top. Trace the letters with pen and ink to get the feel of writing the letters correctly.
- **Work in order.** In each hand there are families of letters. It is easier to practice and learn these alphabets in the family order. (That's the way they are presented on the worksheets.) Become confident with the strokes in one family and then take on the next. If you reach a point where you want to create your own alphabet, being aware of the family groups will help you to create a consistent alphabet that goes together.
- **Concentrate.** Remember to focus each time you set the pen to paper. Check the pen angle, breathe, and make your stroke. If you do this every time you write, you will learn quicker.

BASIC STROKES

Almost every letter is made up of one or more basic strokes. Practice them and get comfortable with them. For the examples, I'm using a chisel tip nib. Don't worry about the specific angle of the pen at this point but do try to keep the angle consistent; just get the feel of the pen and the ink together. The same applies if you are working with markers.

Down Stroke

To make the down stroke, place the pen on the paper and pull down. If you aren't getting a crisp line on both sides you are not making contact evenly.

When you are making strokes, think of your hand and wrist as one unit. Don't try to do the strokes with your fingers. Pull down with your whole hand.

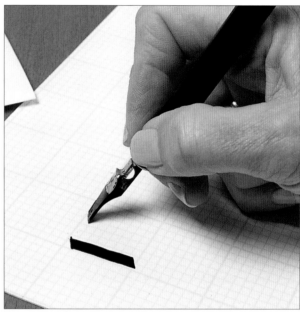

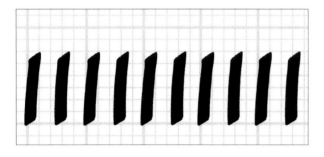

Down stroke.

Extended Down Stroke

An extended down stroke is simply a longer version of the down stroke. Don't forget to breathe, especially on these. Get into the habit of using your whole hand and arm as one unit. If you use only your fingers, you will only be able to write small, and you will tire quickly.

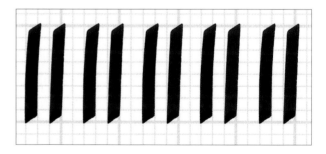

Horizontal Stroke

To make the horizontal stroke, move the pen from left to right. Notice how the thickness of the stroke changes when you change direction.

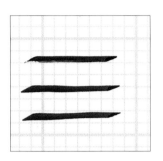

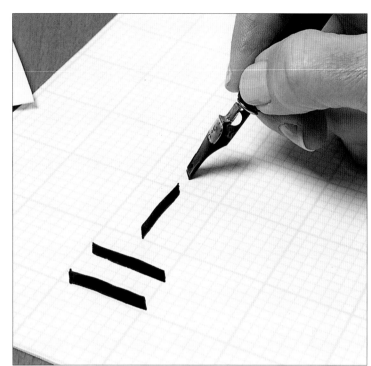

Horizontal stroke.

Curved Stroke

To make the curved stroke, move the pen from top to bottom. Note how the width changes as you stroke. Use your whole hand. If you use only your fingers, it's difficult to complete the curve - you'd have to readjust your hand and pick up the stroke, which would make your work look choppy.

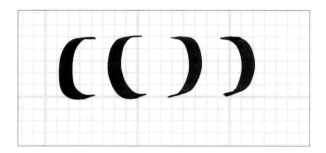

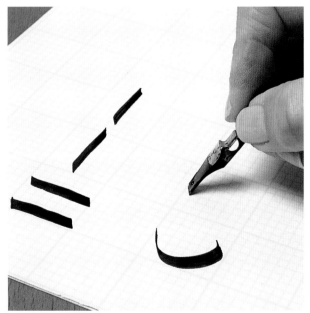

Starting the curved stroke.

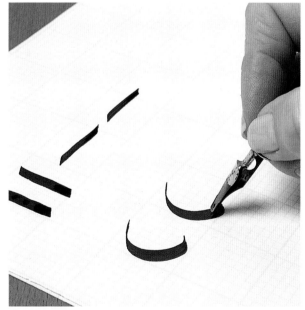

Completing the curved stroke.

49

Basic Strokes, continued

Diagonal Strokes

Diagonal strokes move the pen from top to bottom on a slant. The thickness of the line you make depends on whether you are working from left to right or right to left.

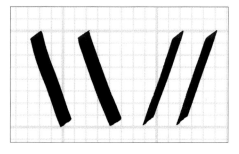

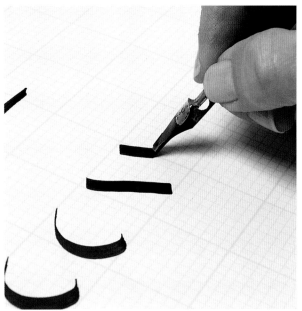

A diagonal stroke, working from top left to bottom right.

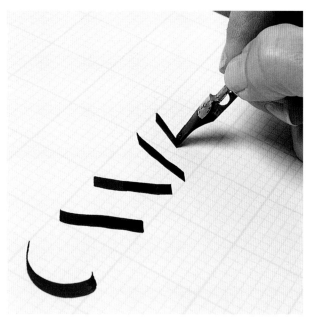

A diagonal stroke, working from top right to bottom left.

Warm Up Strokes

Try these strokes to warm up and familiarize yourself with the pen and ink. Go ahead - make some fun patterns!

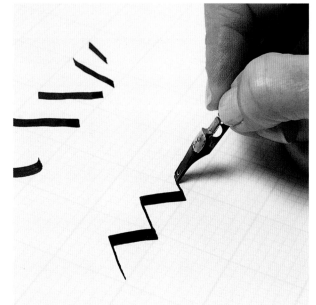

The M Stroke is one warm up stroke.

Beginning Strokes Practice Sheet

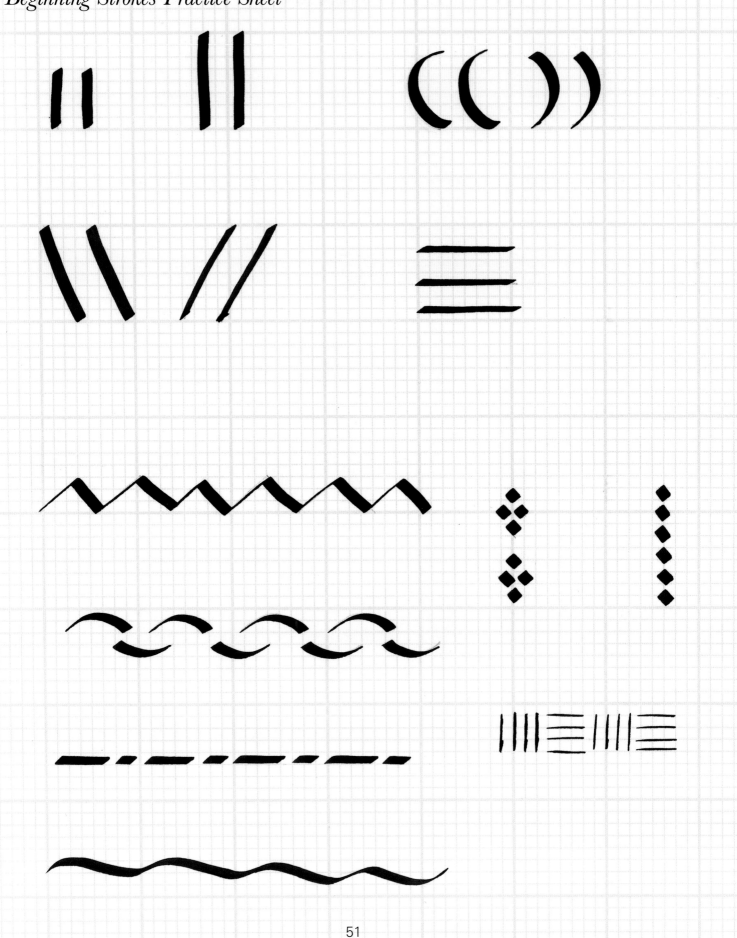

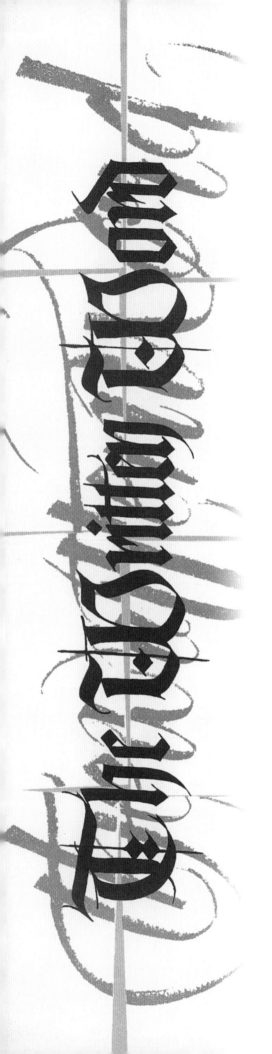

Gothic Alphabet

The Gothic hand is also known as Black Letter and Textura, and used to be called Old English. This is the hand that drew me to calligraphy. It is identified by its strong straight lines and tight spacing known as picket-fence spacing, which means that the space between each letter is the same as the space inside the letter, creating the look of (you guessed it) a picket fence. The interlinear space is tight.

The lowercase is relatively simple, but Gothic capitals can be very decorative - they are much more open than the lowercase letters and provide breathing space in the body of gothic writing. Old gothic manuscripts had very decorative, drawn-in capitals. Some even have miniature paintings. Gothic capitals make beautiful monograms and are well suited to masculine pieces. Gothic writing was used primarily from the 12th to 15th centuries. I love the dark, straight, heavy look that conjures up thoughts of vampires, castles, and Transylvania.

The Gothic hand is difficult to read, but it creates great textures and patterns for a block of writing and makes for very dramatic single words. You can use other capitals with this hand for a more decorative touch - Lombardics and Versals look great.

ESSENTIALS

Pen Angle - 40 degrees
Slant - Vertical
Pen Widths - 5 pen widths (6-1/2 for ascenders and descenders, 5 to 7 nib widths for capitals)

Family groups - Although the family groups are not as defined in this hand since almost all the lines are straight, it would be easier to learn the letters in this sequence: i, j, l, t n, u, v, o, b, c, d, e, f, g, h, k, p, q, p, r, s, w, x, y, z, and a.

Calligraphy at left by Molly Gaylor, Gothic alphabet done with broad edge pen and ink.

Opposite page: Calligraphy by Virginia Farr-Jones.
Gothic alphabet done with Walnut Ink on watercolor paper.

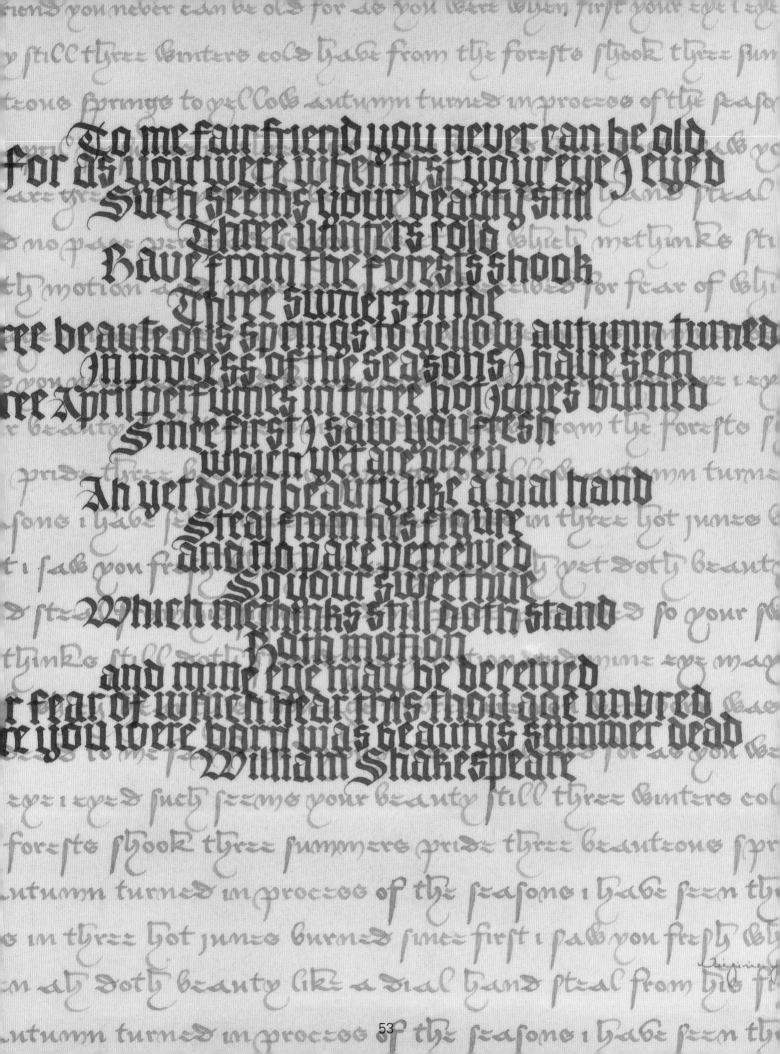

MAKING THE LETTERS

This photo series shows how to make a lowercase letter "h."

Type of Pen

The exemplar was done with a Brause 4mm nib; the title and colored words were done with a Brause 3mm. I used black ink and watercolor paints.

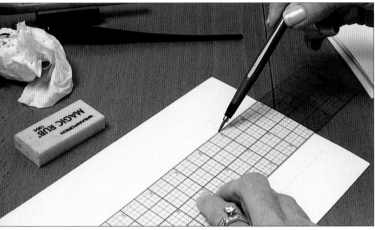

1. Line up your paper, allowing 5 pen widths from waist to base.

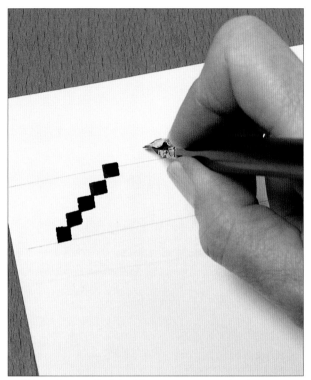

2. To make an "h," hold your pen at a 40 degree angle and start the first downstroke.

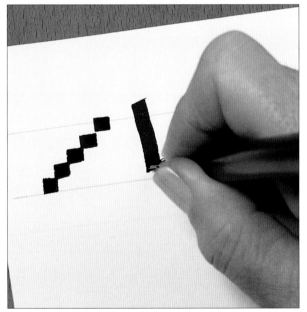

3. Complete the downstroke.

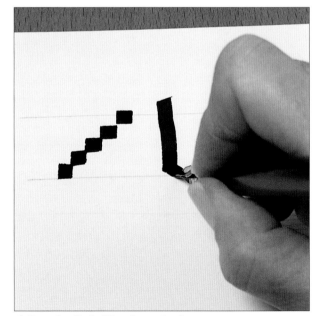

4. Put the little "foot" on the bottom.

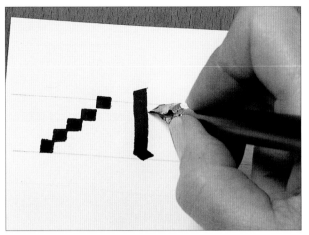

5. Start the cross stroke.

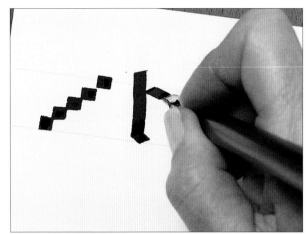

6. End the cross stroke.

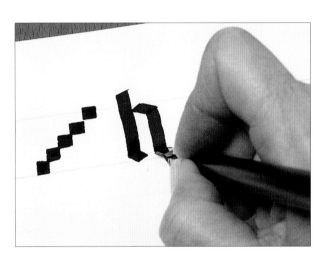

7. Make the downstroke. Finish with another "foot" at the end of the stroke.

Below: by Marci Donley, Gothic alphabet, *Pursue Life* done in gouache and ink on watercolor paper, steel nib and automatic pen.

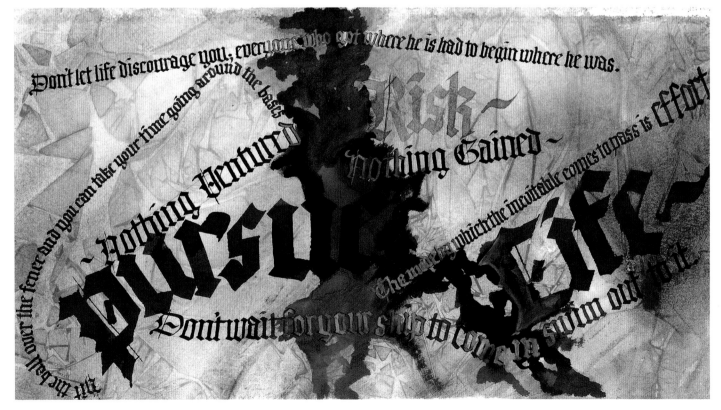

Gothic

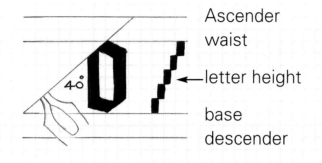

Ascender
waist

letter height

base
descender

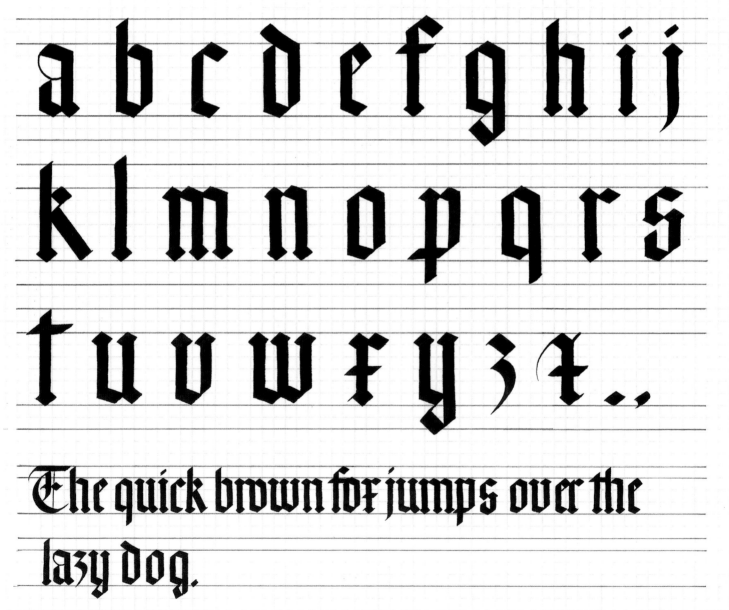

a b c d e f g h i j

k l m n o p q r s

t u v w x y z & ..

The quick brown fox jumps over the
lazy dog.

Virginia Jane Jones 05

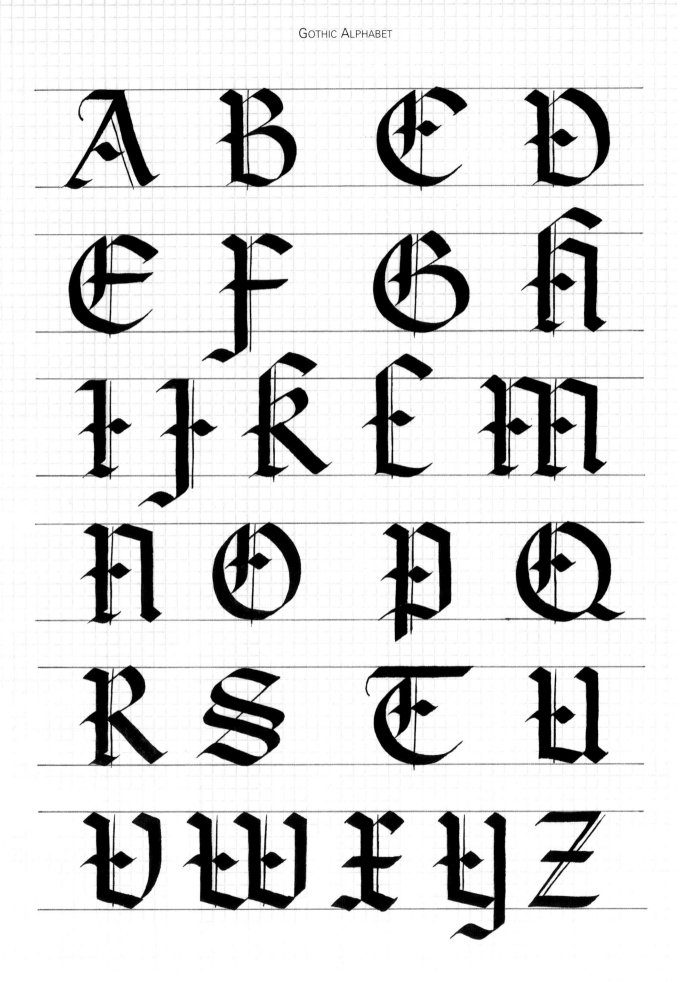

57

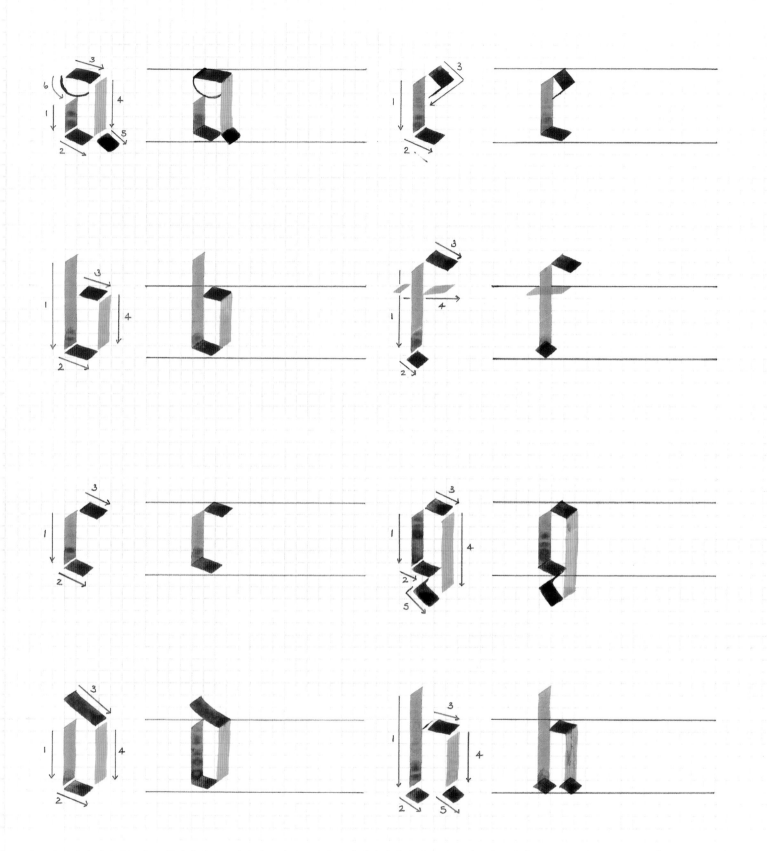

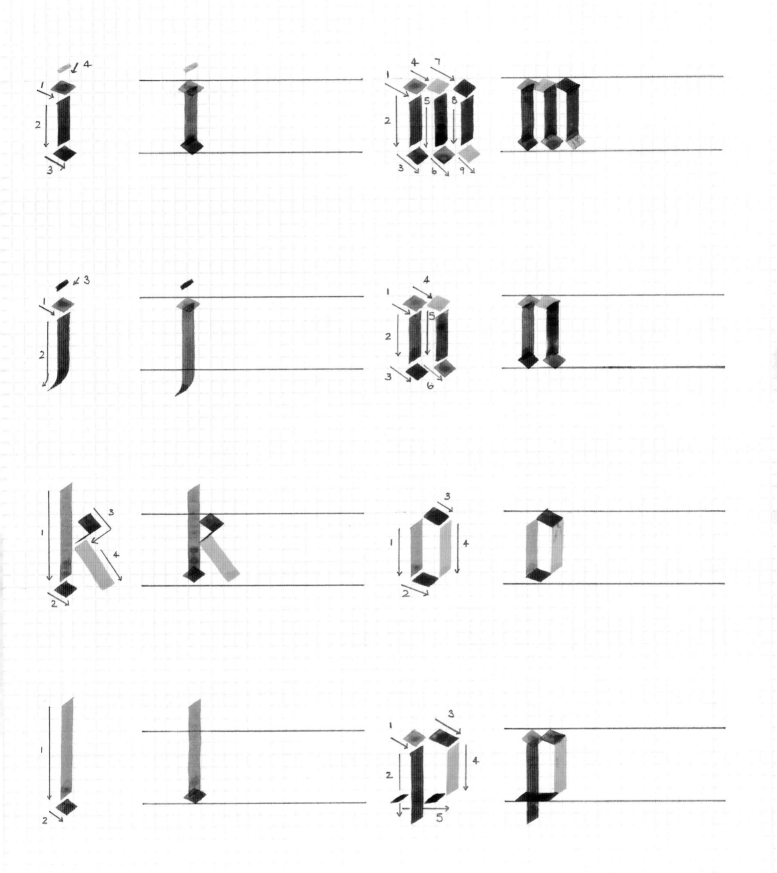

Virginia Farr Jones 05

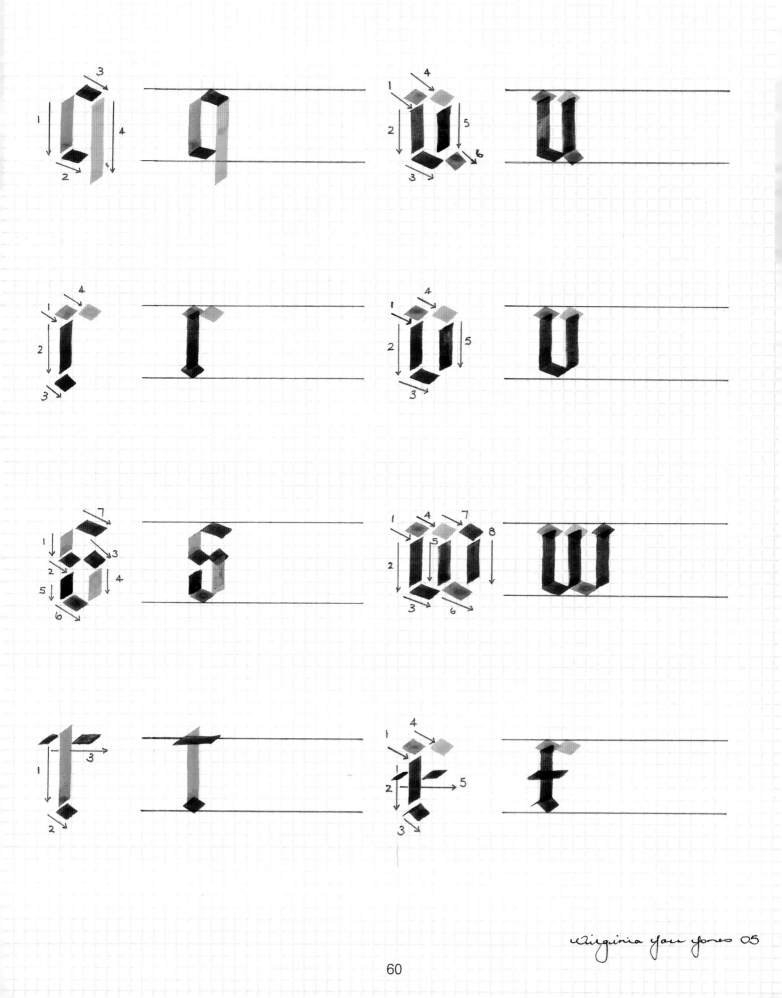

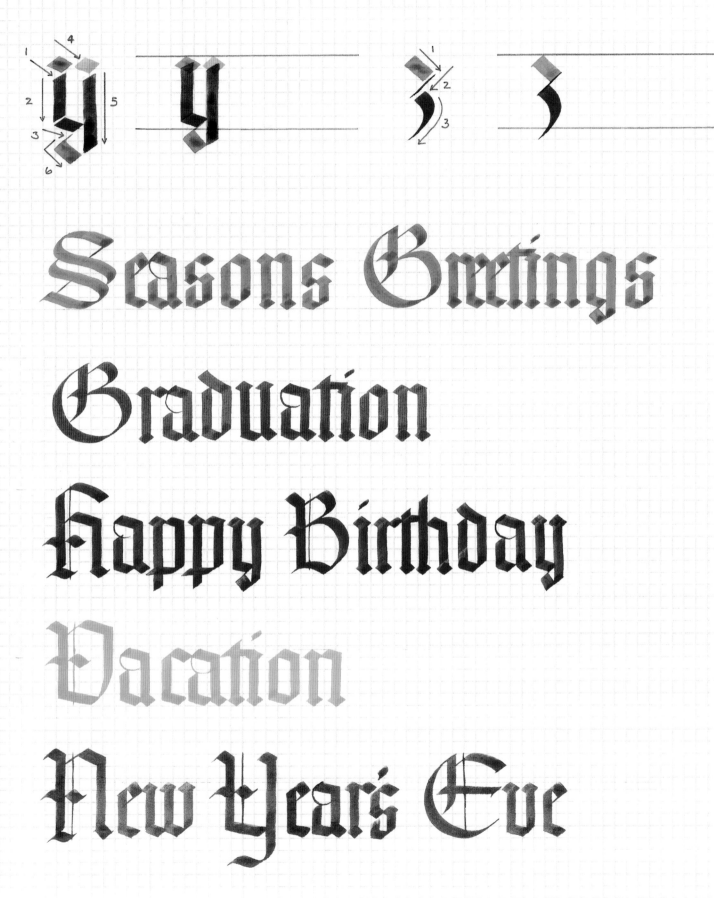

Seasons Greetings

Graduation

Happy Birthday

Vacation

New Year's Eve

Virginia Fall Jones 05

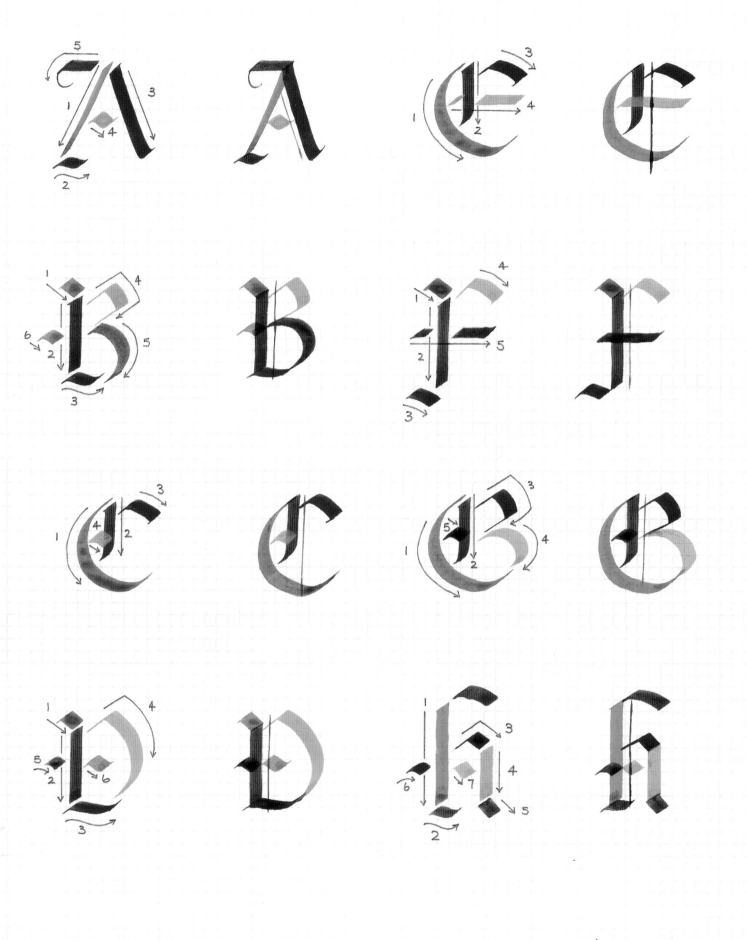

Virginia Yare Jones 05

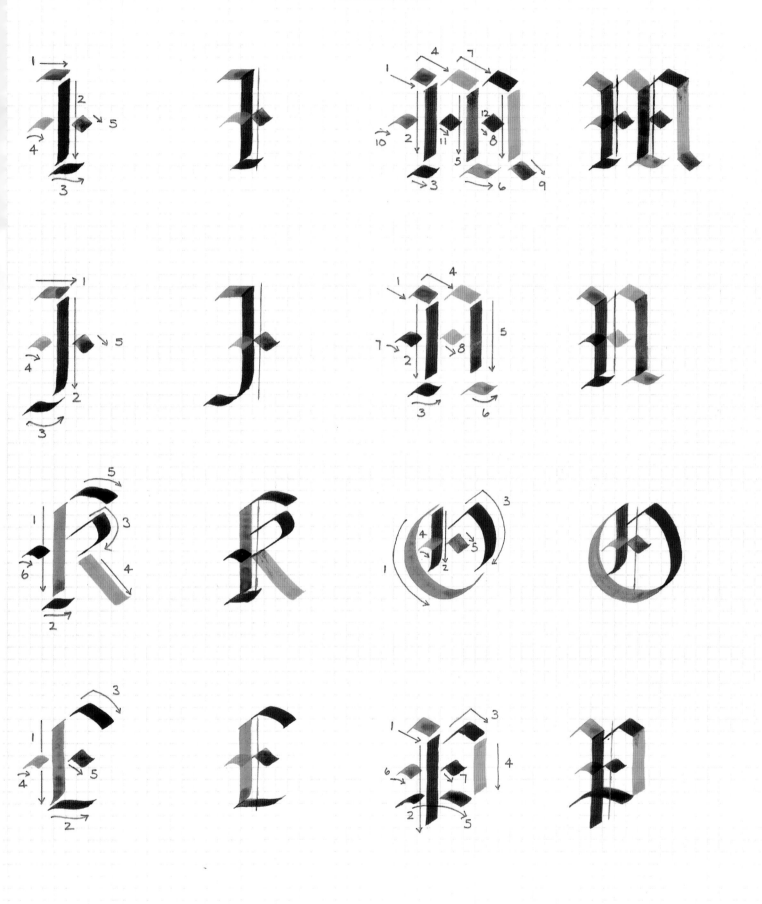

Virginia Jane Jones 05

63

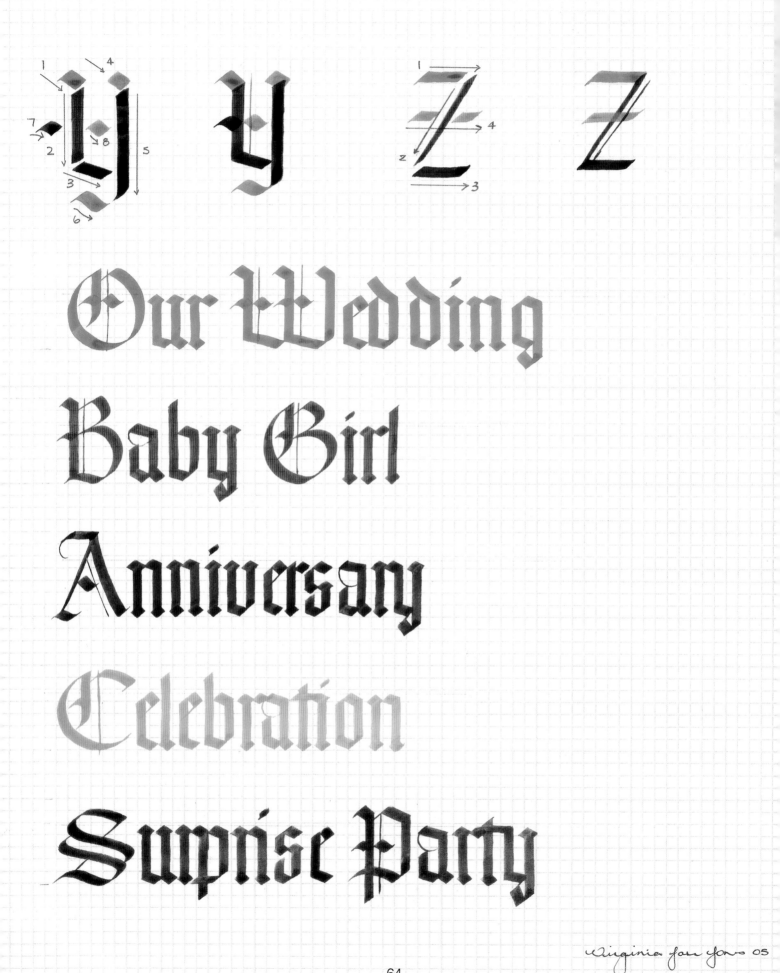

Our Wedding

Baby Girl

Anniversary

Celebration

Surprise Party

Virginia Jan Jones 05

a A

Worksheet

Italic Alphabet

When people think of calligraphy they usually think of a flourished Italic. This beautiful hand serves many purposes. It is distinguished by the elliptical shape of the "o" (it is not rounded) and by the branching strokes of letters such as "a," "b," and "n." The hand has a slightly forward (but not steep) slant of about 5 degrees.

You may see the Italic hand referred to as Chancery or Italic Cursive. It originated in the Italian Renaissance, providing a hand that was easy and fast to write. The uppercase letters, an informal adaptation of the Roman Capitals, are compressed and on a slight slant. Italic is another picket fence spaced alphabet. The "n" is the basis for the spacing. The interlinear space should be about two times the x-height so you can avoid the ascenders and descenders colliding.

The Italic hand can be used to form some wonderful looking and expressive alphabets. A good Italic hand is useful; specifically, if you can write "Mr. and Mrs." beautifully, it will serve you very well for addressing envelopes.

ESSENTIALS

Pen angle - 45 degrees (diagonally through a square)
Slant - 5 degrees
Pen Widths - 4-1/2 to 5 at x-height; 3 pen widths for ascenders and descenders or ascenders and descenders equal to x-height

Family Groups -
 i, l, f, t, j
 o, e, c
 n, m, h, k, r, b, p
 u, a, y, g, q, d
 v, w, x, z.
 Orphan - s

The capital letters have slightly different families.

Left: Calligraphy by DeAnn Singh, Italic alphabet done with watercolors and steel nibs.

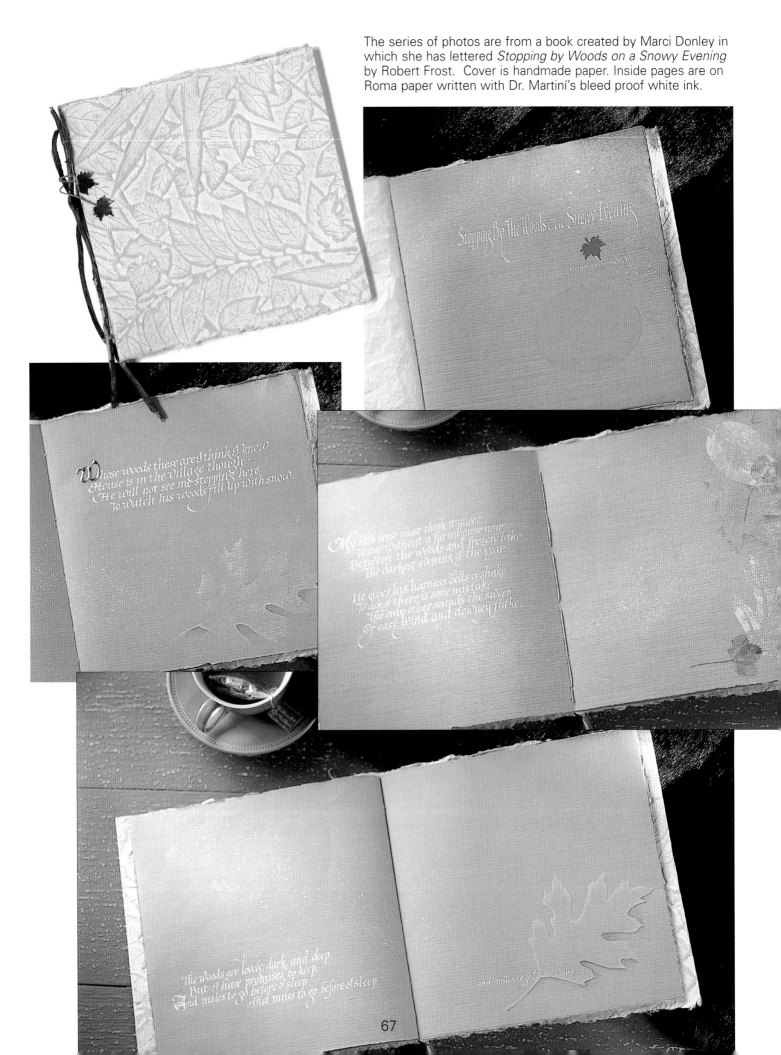

The series of photos are from a book created by Marci Donley in which she has lettered *Stopping by Woods on a Snowy Evening* by Robert Frost. Cover is handmade paper. Inside pages are on Roma paper written with Dr. Martini's bleed proof white ink.

MAKING THE LETTERS

This photo series shows how to make a lowercase Italic "h" or "b."

Type of Pen

This exemplar is done using a Speedball C-2 pen, with ivory black gouache and watercolor paints.

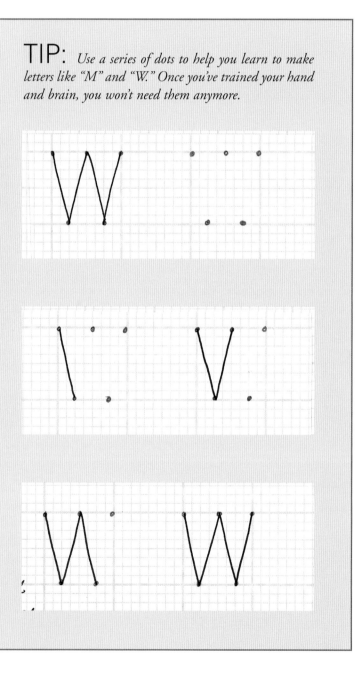

TIP: *Use a series of dots to help you learn to make letters like "M" and "W." Once you've trained your hand and brain, you won't need them anymore.*

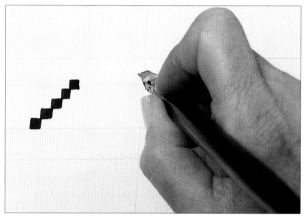

1. Line your paper for an x-height of 4-1/2 to 5 pen widths. Hold your pen at a 45 degree angle.

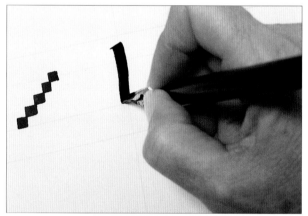

2. Make the stem stroke.

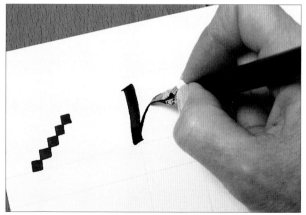

3. Go back up the stem stroke and branch off about halfway way up the x-height.

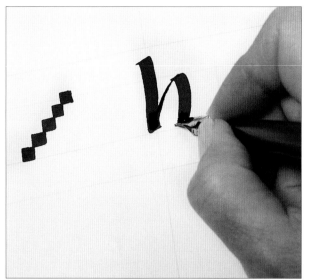

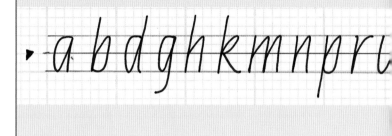

TIP:

- *Entrance serif is sharp. Exit serif is rounded slightly.*

- *Branching letters exit at halfway up the stem, not before.*

- *All branching letters should branch at the same point for consistent look.*

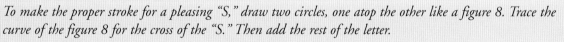

4. At this point this letter could be a "b" or an "h." If the stem were shorter, it could be an "n."

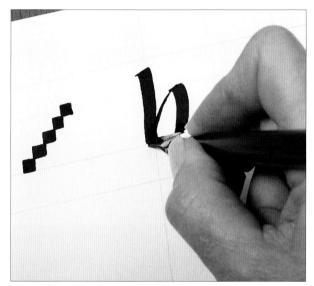

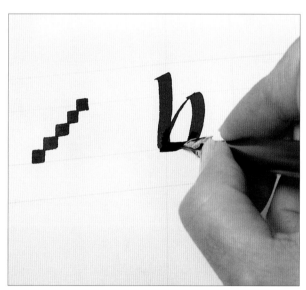

5. To form the bottom of the bowl of the letter "b," you can continue the stroke and push it to the stem.

6. Or you can move your pen and take the stroke from the bottom of the stem stroke to join the bowl.

TIP:

To make the proper stroke for a pleasing "S," draw two circles, one atop the other like a figure 8. Trace the curve of the figure 8 for the cross of the "S." Then add the rest of the letter.

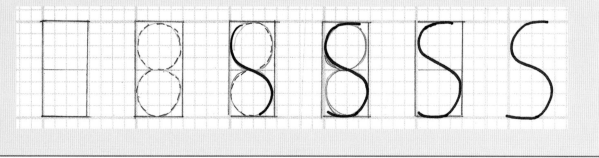

Italic
lower case

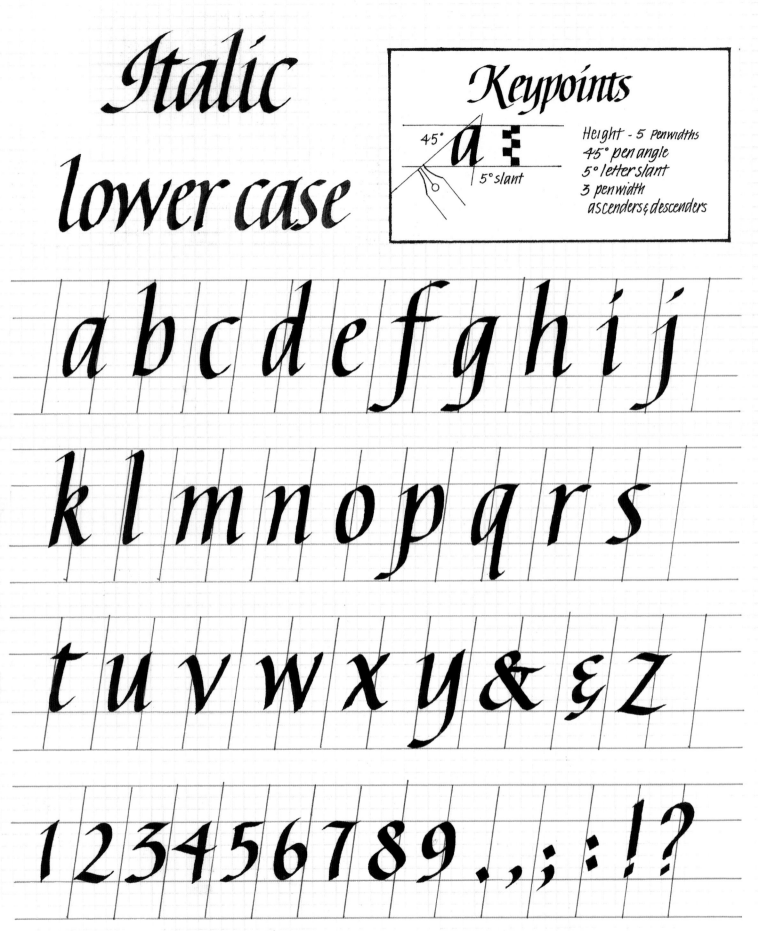

a b c d e f g h i j

k l m n o p q r s

t u v w x y & ℰ z

1 2 3 4 5 6 7 8 9 . , ; : ! ?

written out with Speedball C-2 pen

carrie imai '05

Italic Capitals

written at 7 pen widths tall with Speedball C-2 pen

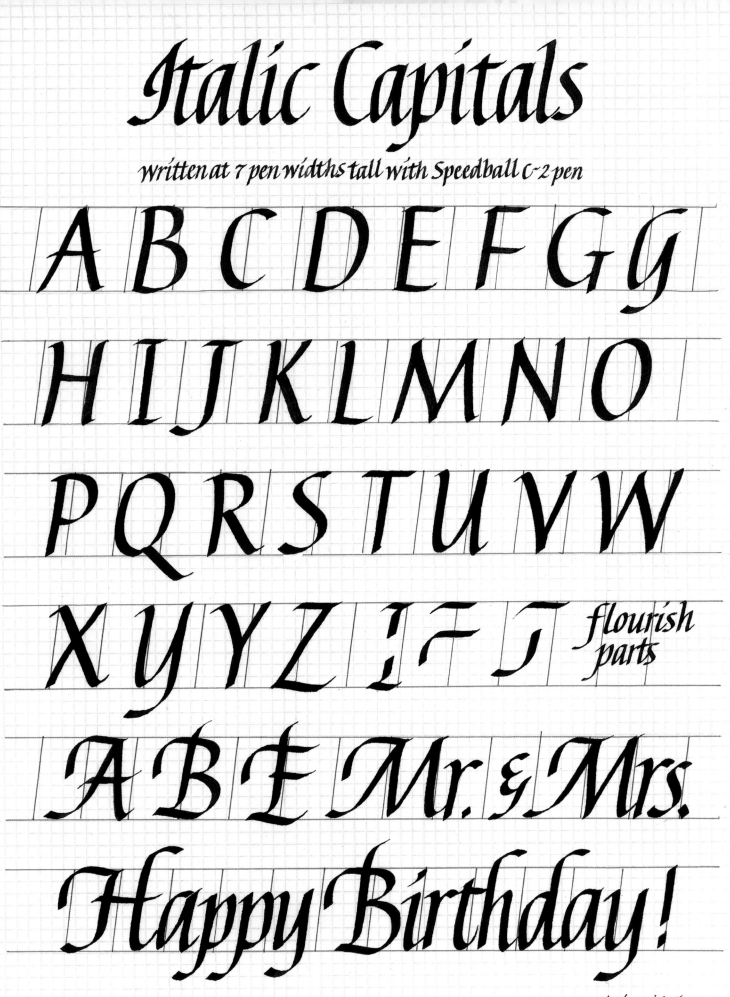

A B C D E F G G

H I J K L M N O

P Q R S T U V W

X Y Y Z I F J *flourish parts*

A B E Mr. & Mrs.

Happy Birthday!

carrie imai '05

Worksheets

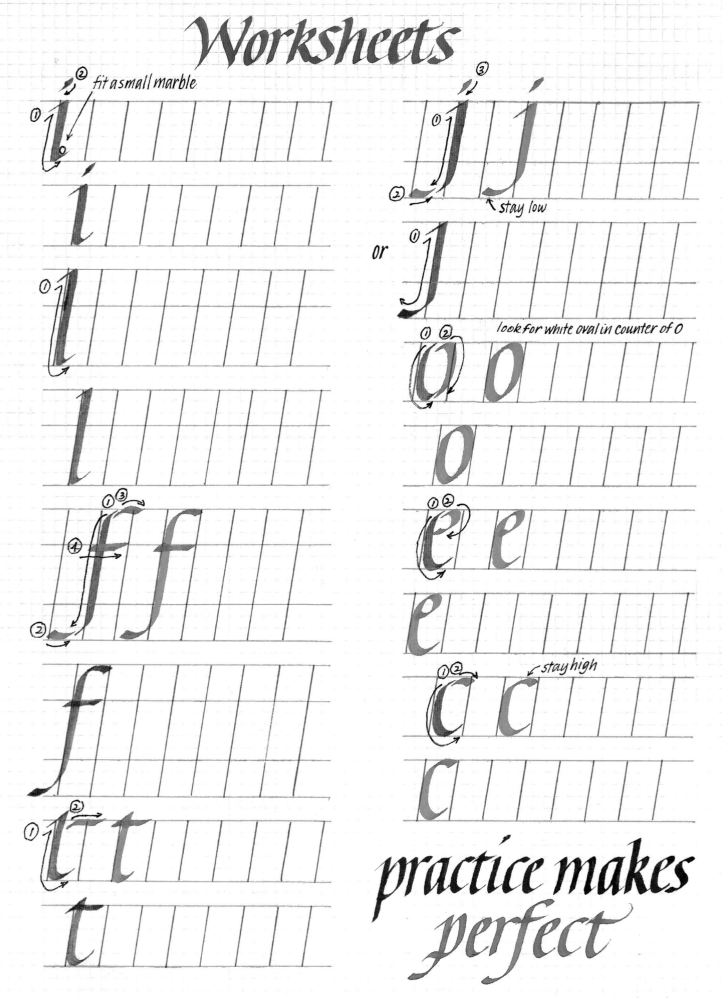

fit a small marble

stay low

or

look for white oval in counter of O

stay high

practice makes
perfect

carrie imai '05

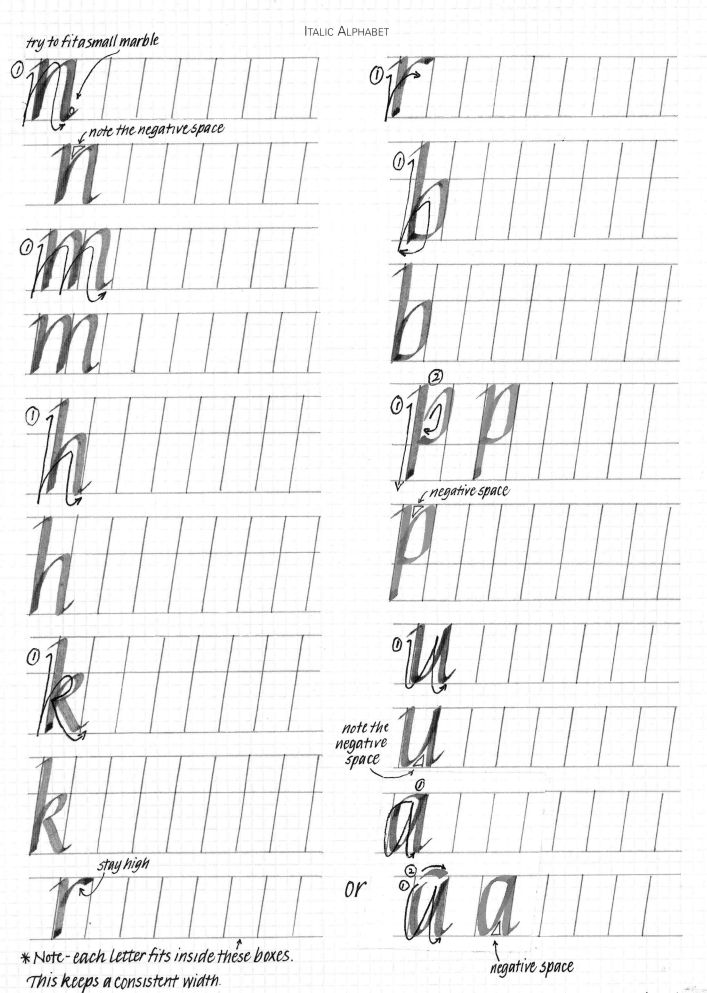

try to fit a small marble

note the negative space

① m
n

① m
m

① h
h

① k
k

stay high
r

① r

① b
b

① p ② p
p

negative space

① u

note the negative space

① a

or ① ② a

negative space

* Note – each letter fits inside these boxes.
This keeps a consistent width.

carrie imai '05

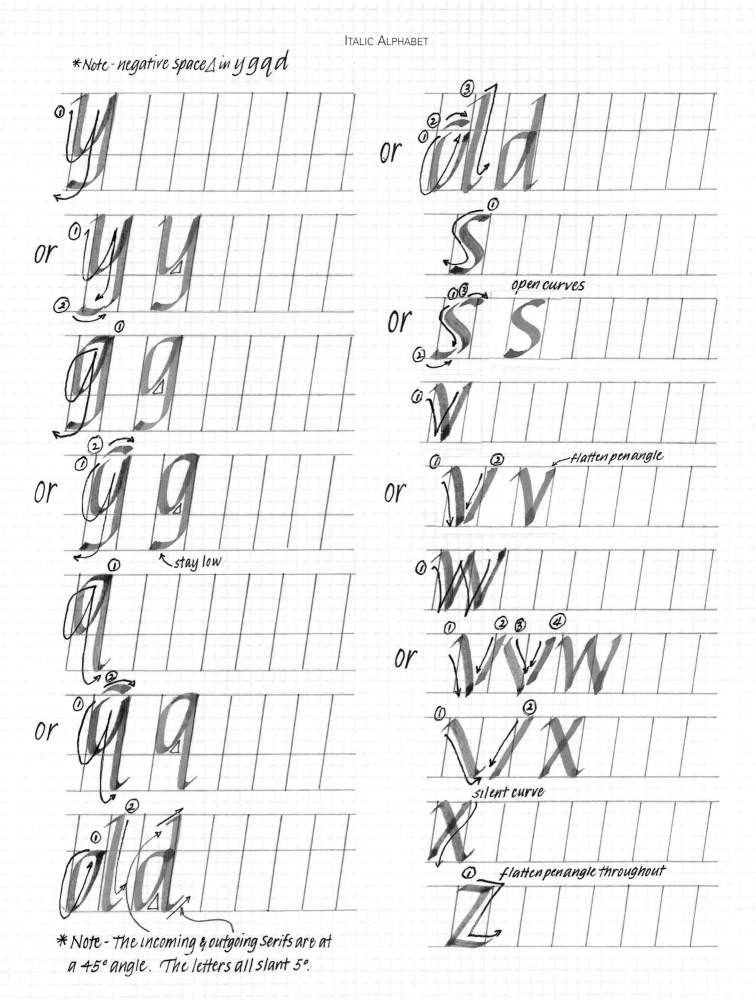

*Note - negative space △ in y g q d

or

open curves

stay low

or

flatten pen angle

or

silent curve

or

flatten pen angle throughout

* Note - The incoming & outgoing serifs are at a 45° angle. The letters all slant 5°.

carrie imai '05

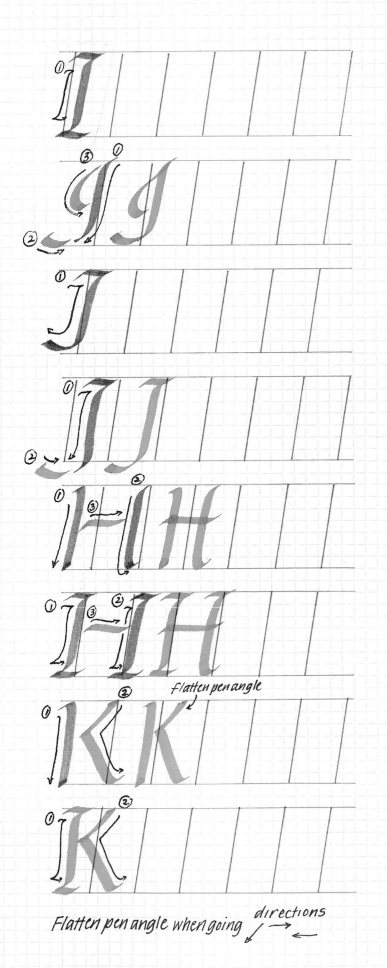

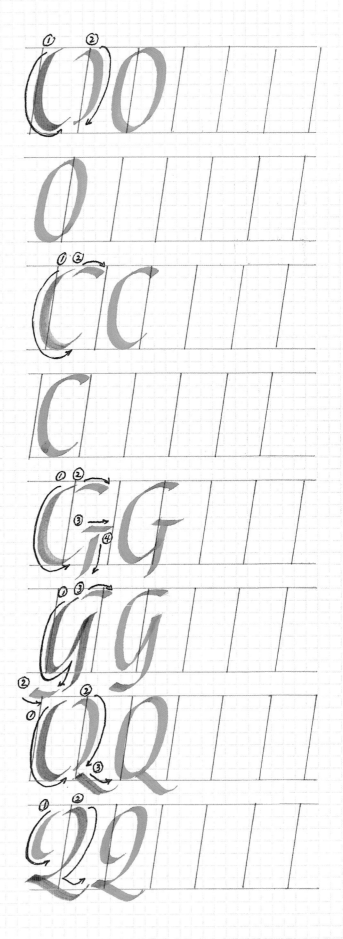

Flatten pen angle

Flatten pen angle when going directions

carrie imai '05

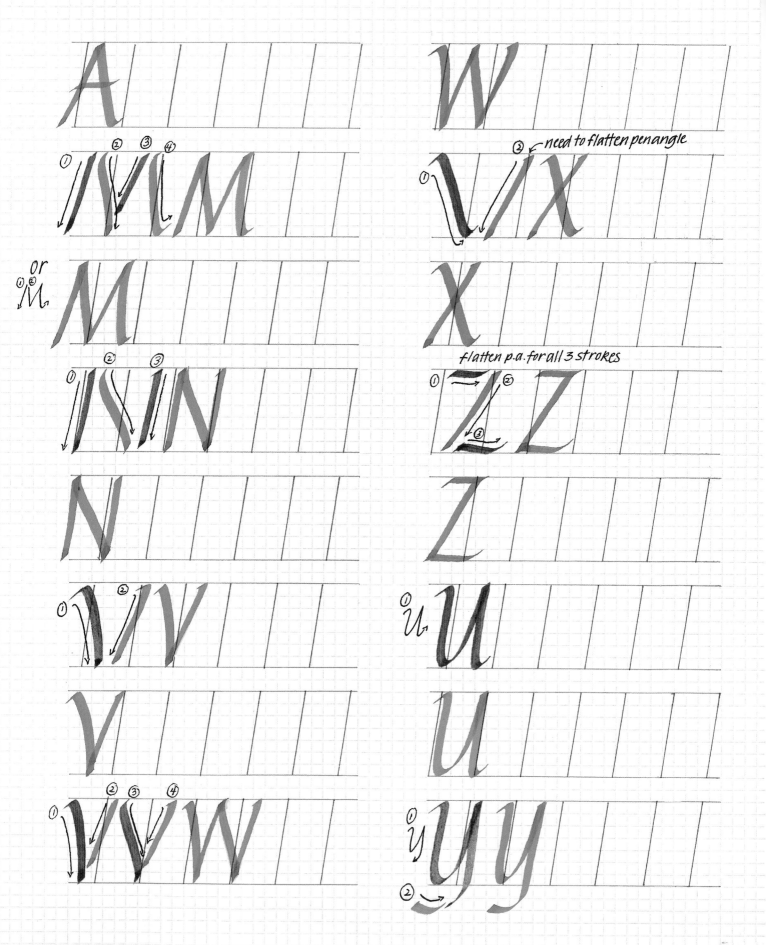

need to flatten penangle

flatten p.a. for all 3 strokes

carrie imai '05

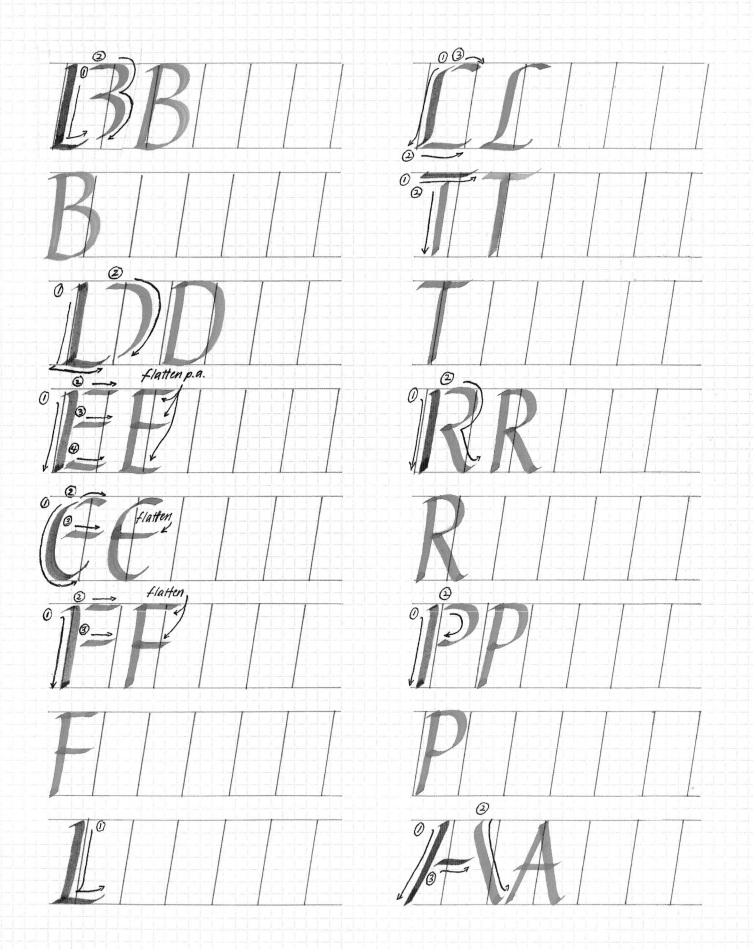

flatten p.a.

flatten

flatten

carrie imai '05

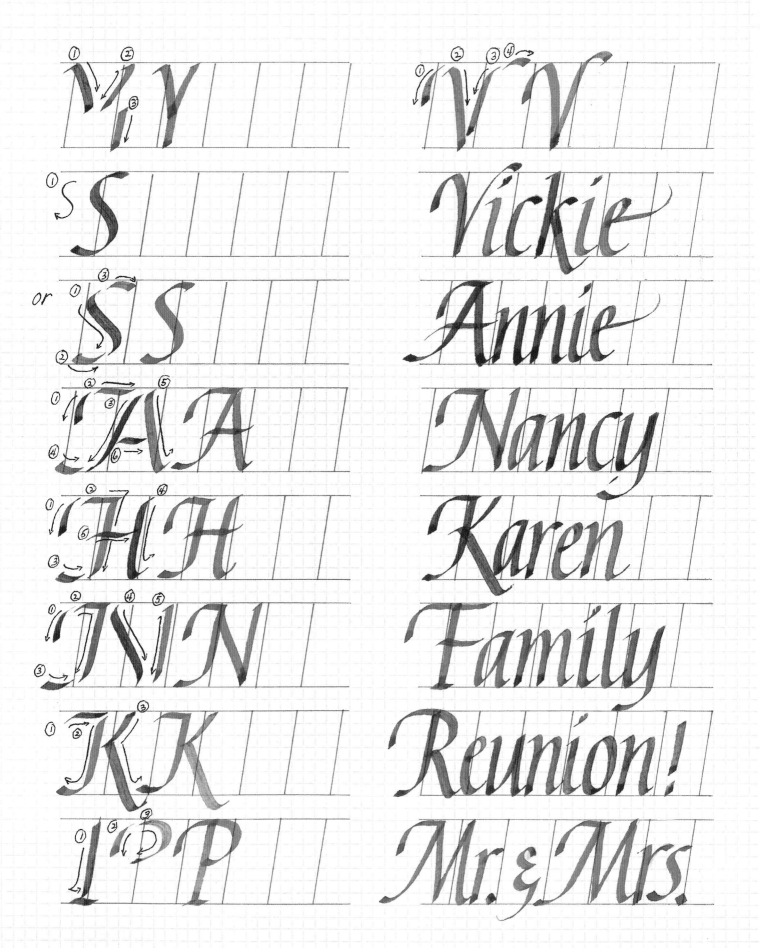

Y Y

S

or S S

A A

H H

N N

K K

P P

V V

Vickie

Annie

Nancy

Karen

Family

Reunion!

Mr. & Mrs.

carrie imai '05

Playsheet

The quick brown fox jumped over the lazy dog

Note the eveness of the spacing, the consistent letter slant & width.

Using a dip pen allows you to use gouache, acrylic & watercolor in your pen.

don't get tight play

play

Learn the rules THEN
Let the letters dance

Learning calligraphy is a journey
Practice, use it daily. Write a letter
to a friend or make
them a beautiful
envelope. They
will feel special.

Have FUN

Relax

breath

Staying
in
the
LINES
is
like
dancing
in
a
CLOSET

carrie imai '05

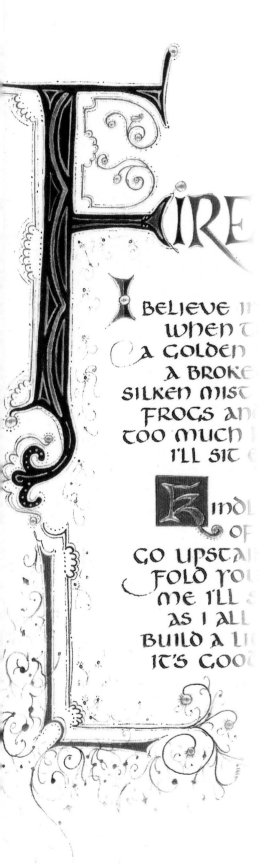

Uncial Alphabet

Uncial was used mostly as a book hand between the 3rd and 9th centuries for manuscripts and Christian texts. Over the years that the Uncial hand dominated, there were several variations, including the Insular Half Uncial used in the Book of Kells.

Today, Uncial still holds up as a suitable hand for writing blocks of text. The Uncial hand is a majuscule alphabet (meaning it is a capital form) and has no minuscule forms. You can use a slightly larger form of the letter as a capital if you like.

Think of the Uncial hand as a string of pearls - the letters are very rounded and wide. They should be spaced close together but not packed in too tightly. They don't need much interlinear space.

Try using this hand for religious writing or Irish quotes. It looks great with Celtic drawings and lots of colors in the counter spaces. These beautiful letters will add a beautiful touch to your writing.

ESSENTIALS

Pen Angle - 20 degrees (You can adapt to between 15 and 30 degrees.)
Slant - Vertical (straight up and down)
Letter shape - Basic shape "O" is wider than a circle (think of a grapefruit). This is a round letter hand.
Pen Widths - 4 pen widths to the body of the x-height, 1 pen width above or below for extenders

Family groups:
I, J, L, T, K, N
V, X, Y, Z
C, E, G, O, Q, D
U, W, M, H B, P, R
and F
Orphans - A, S

Calligraphy left, Marci Donley, *Fire at Midnight,* done with gouache on watercolor paper with steel nibs.

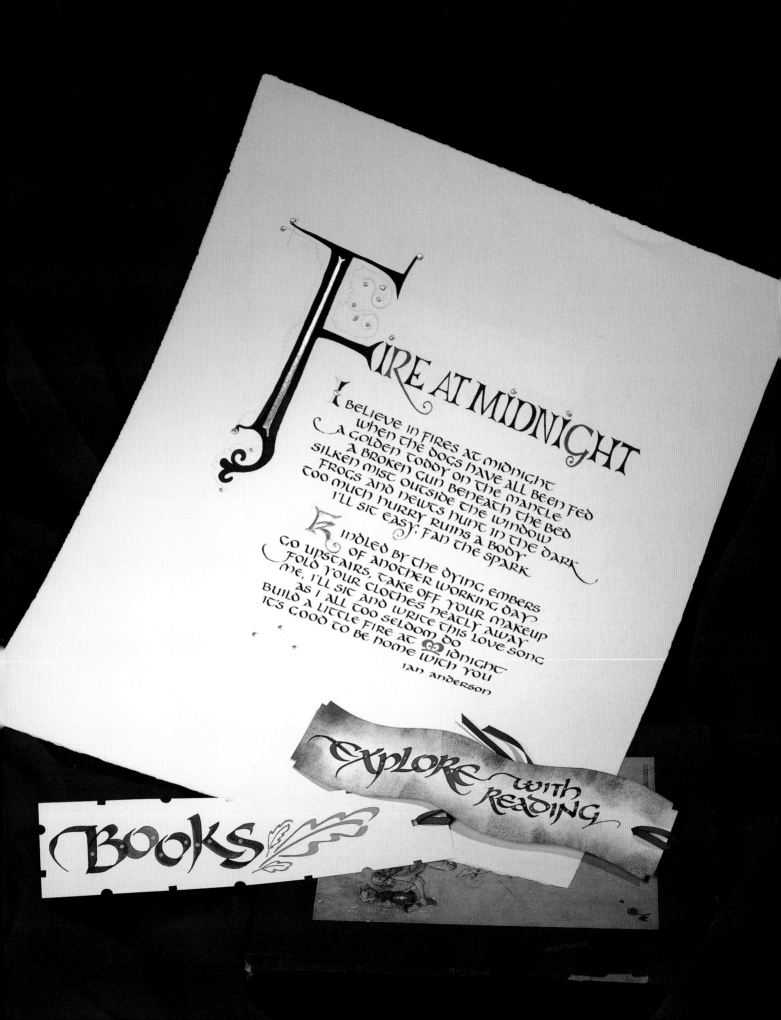

Fire at Midnight

I believe in fires at midnight
when the dogs have all been fed
A golden toddy on the mantle
A broken gun beneath the bed
Silken mist outside the window
Frogs and newts hunt in the dark
Too much hurry ruins a body
I'll sit easy, fan the spark

Kindled by the dying embers
of another working day
Go upstairs, take off your makeup
Fold your clothes neatly away
Me, I'll sit and write this love song
as I all too seldom do
Build a little fire at midnight
It's good to be home with you

Ian Anderson

EXPLORE with READING

BOOKS

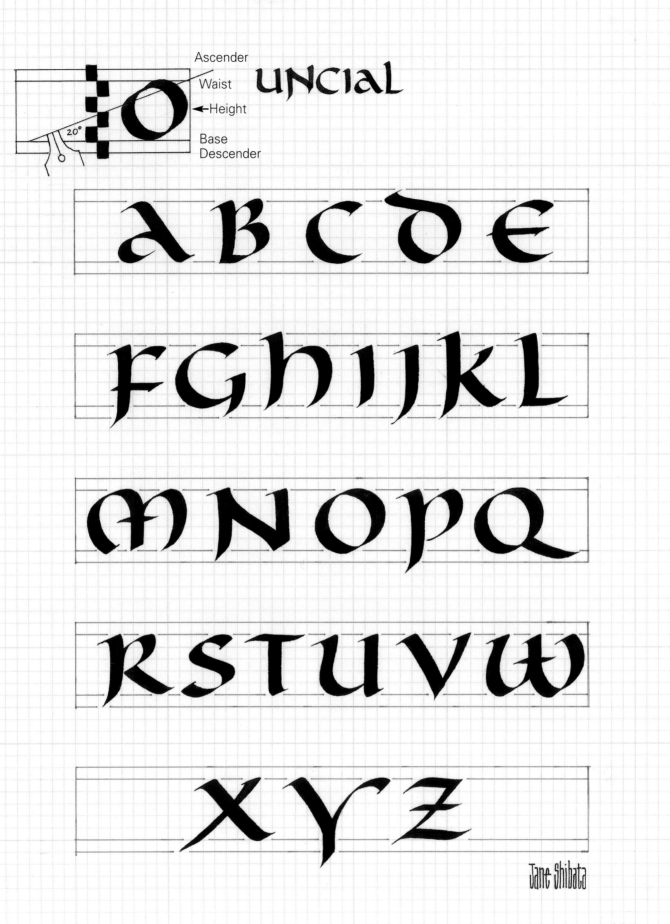

Ascender
Waist
← Height
Base
Descender
20°

UNCIAL

ABCDE

FGHIJKL

MNOPQ

RSTUVW

XYZ

Jane Shibata

What pen?

The following exemplar was done with a 4mm Brause nib. The worksheets were done with markers. The playful bookmark words were done with a parallel fountain pen.

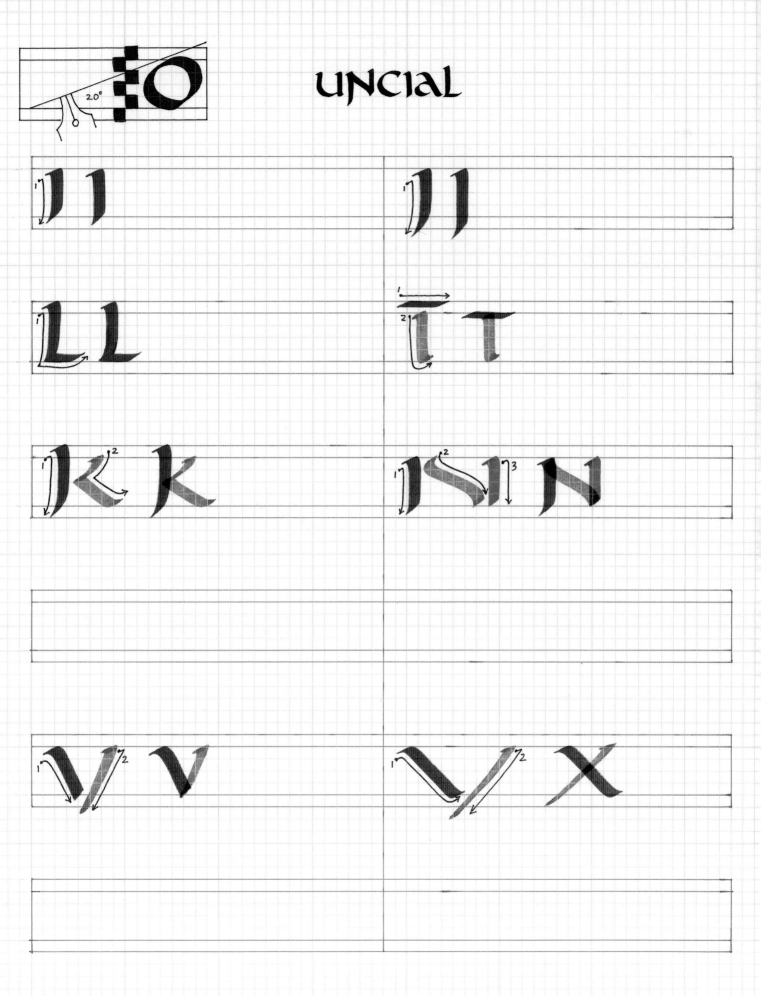

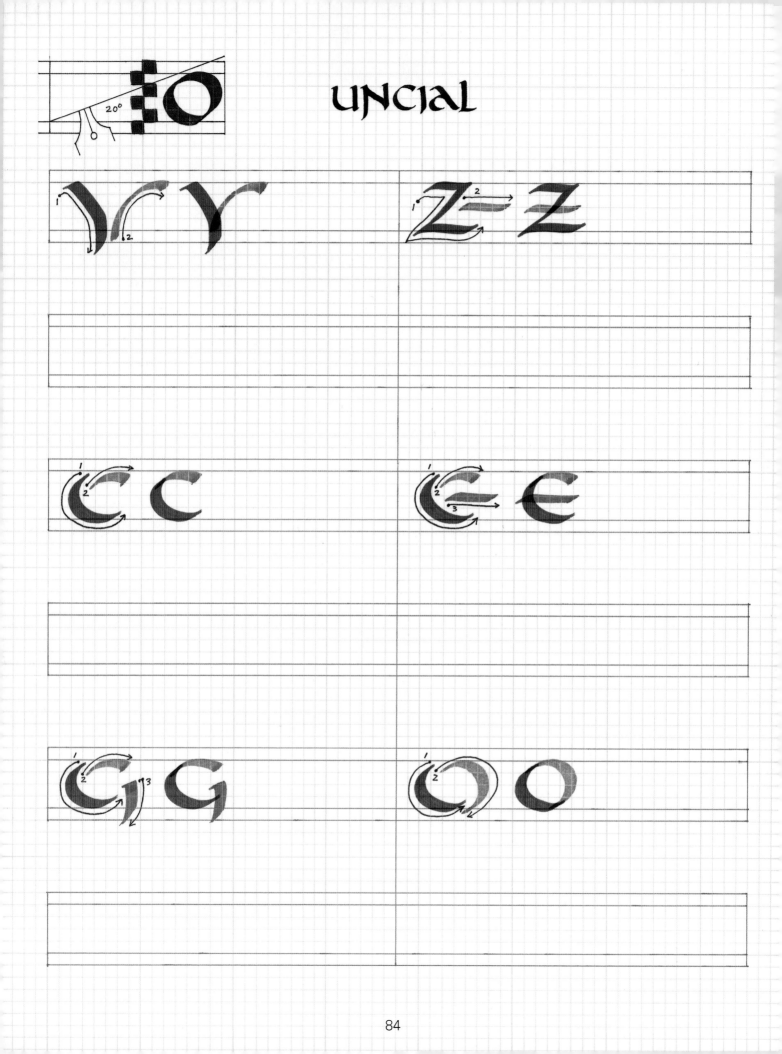

UNCIAL

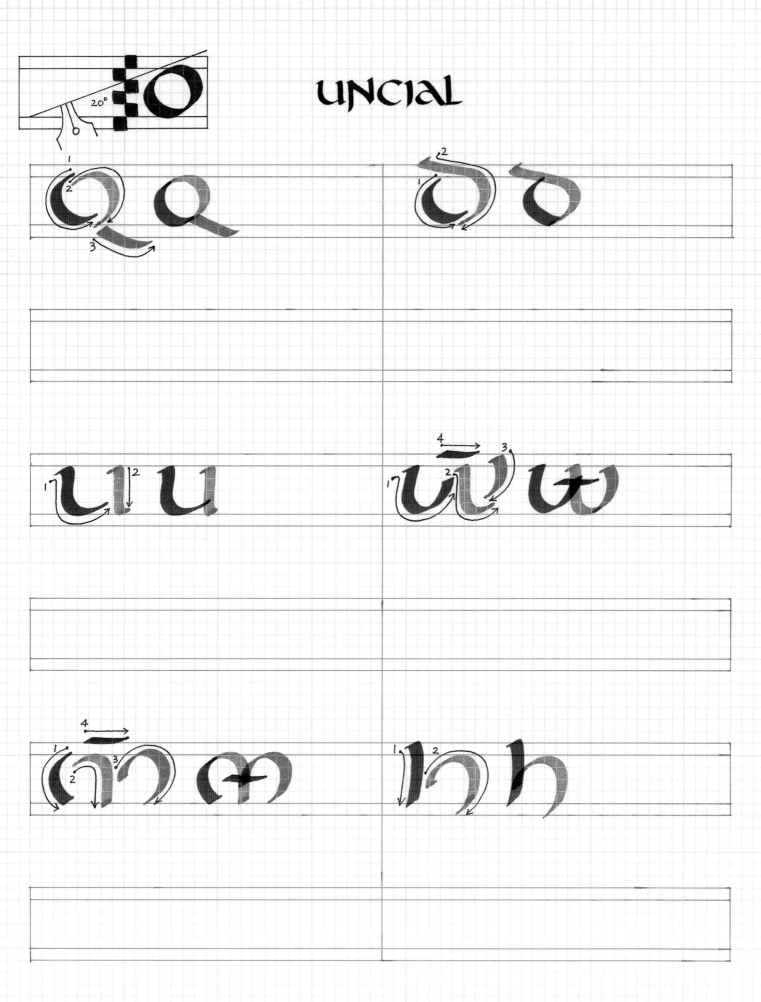

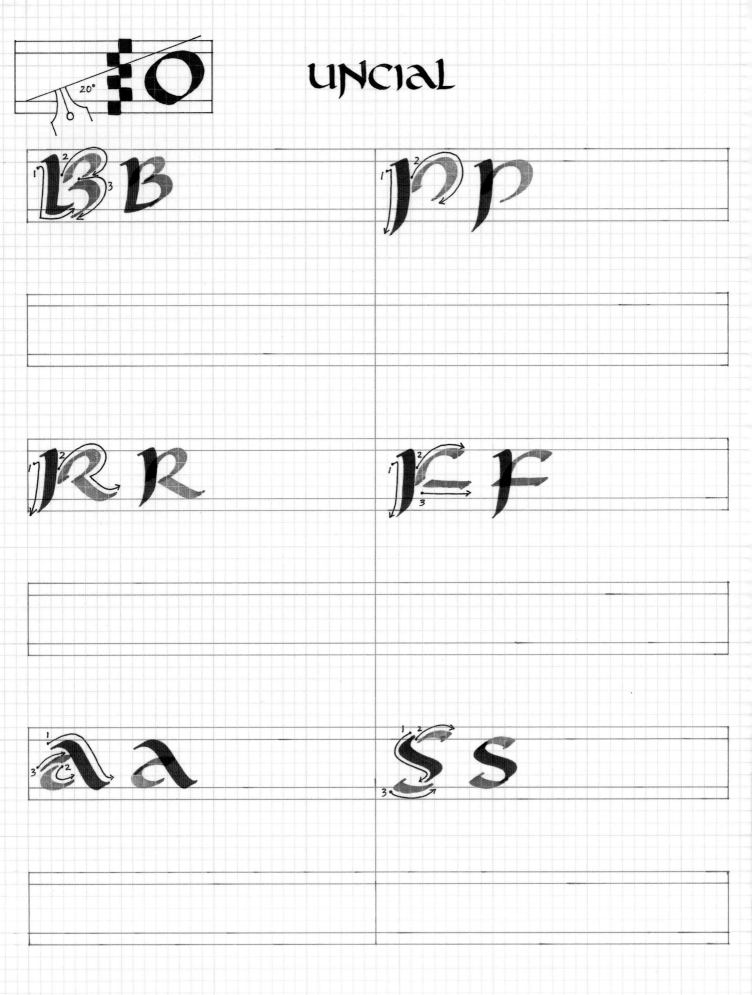

UNCIAL

QUICKLY PACK MY
BOX WITH FIVE DOZEN
LACQUER JUGS.
HAPPY BIRTHDAY
ANNIVERSARY · LOVE
CELEBRATE · PEACE
CONGRATULATIONS
MILESTONES · WINTER
FAMILY VACATION
THANK YOU · SUMMER
MEMORIES · AUTUMN
GRADUATION · SPRING
HAPPINESS IS...

Uncial is a terrific hand for writing a large amount of text. It looks
great with a minimum of inter-linear space. Uncial and monoline
uncial are perfect for journaling, cards, and scrapbooking. It is a hand
you can learn to write quickly.

Creative Variation
Monoline Uncial

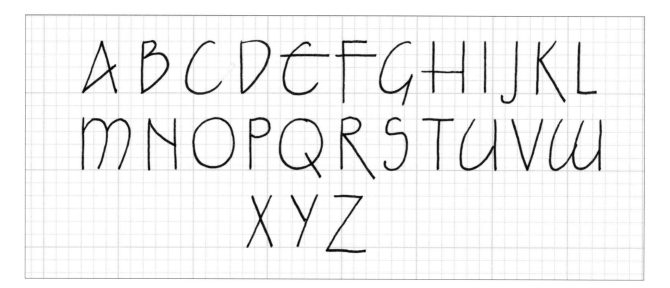

A B C D E F G H I J K L
M N O P Q R S T U V W
X Y Z

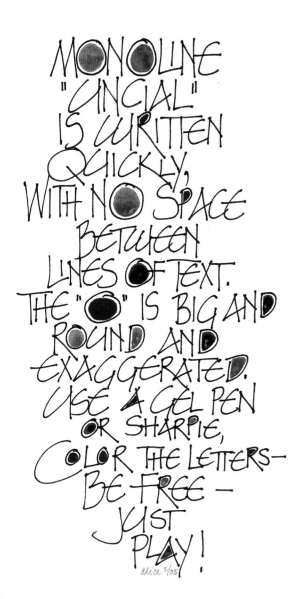

MONOLINE
"UNCIAL"
IS WRITTEN
QUICKLY,
WITH NO SPACE
BETWEEN
LINES OF TEXT.
THE "O" IS BIG AND
ROUND AND
EXAGGERATED.
USE A GEL PEN
OR SHARPIE,
COLOR THE LETTERS—
BE FREE—
JUST
PLAY!

alice 7/05

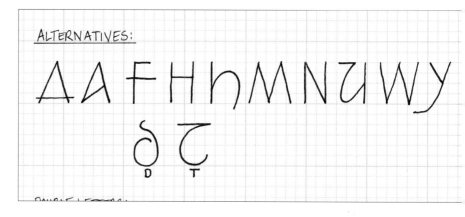

ALTERNATIVES:

A A F H H M N U W Y
δ ζ
D T

DOUBLE LETTERS:

DOUBLE LETTERS:

CH CK EE ET ET LI LL
CH CK EE ET ET LI LL
NN TT TT
NN TT TT

alice Greenthal 2/05

Left: Calligraphy by Alice Greenthal on diploma parchment with pigma pen and watercolors.

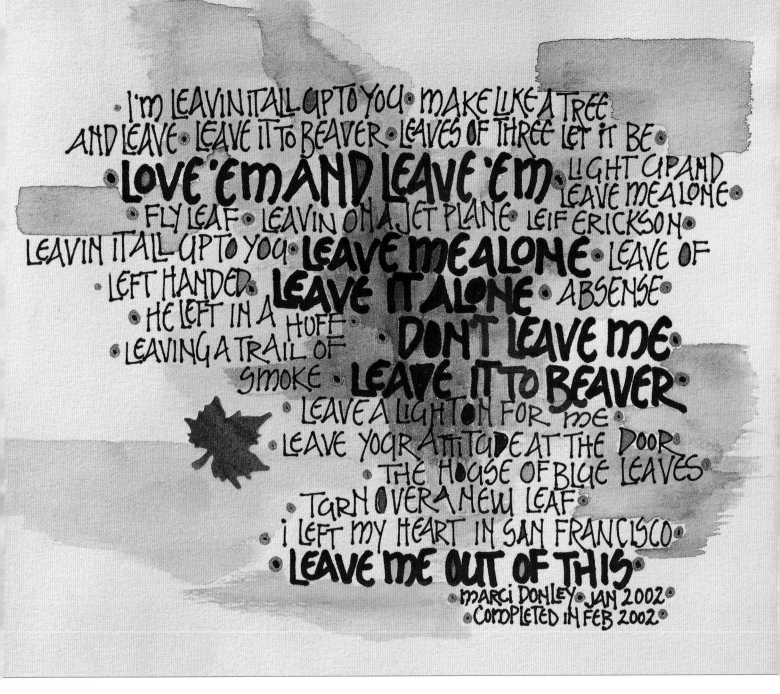

Above: Lettering in monoline uncial on watercolor paper using markers. Watercolors used for background printing.

Monoline Uncial

This alphabet uses the basic shape of the classic Uncial hand. You can write this alphabet in all sizes and colors using an array of tools. The letters can be packed together with very little to no interlinear space. It is a perfect alphabet to color in the Os for accents.

The many monoline markers and paint pens available work great for this alphabet.

Menu

Bisque with Rosemary

in Parmesan Toasts

lmon in Red Onion Crus

lled Lemon Shrimp

ith Spicy Creme Fraiche

atoes with Garlic and Mint

y Tomatoes with Basil

Pepper and Virgin Olive Oil

erts with Walnut Dill Pesto

Potato Dill Rolls

Birthday Cake

Copperplate

Copperplate is done with a pointed pen. The style was named for the process of engraving on copper plates for reproduction, one of the early forms of printing. The thicks and thins are produced by the pressure and release of the flexible pointed pen rather than by the direction and angle of the stroke. The greater pressure and therefore the thicker line is always on the down stroke. Copperplate is written with a significant slant - that's why an oblique pen holder is used.

This style was mostly used from the 16th to 19th centuries and is associated with business documents of the time, which were very decorative so as to command respect. (They had the added bonus of being hard to forge.) Today, this is the script most asked for by brides for their wedding invitations. It can be highly flourished and has a beauty and flow all its own.

The hand is composed of a set of nine strokes that, when put together, form all of the letters. Copperplate is another hand with picket fence spacing. The interlinear space is greater - the ascenders and descenders are so long that there needs to be room for them not to tangle. Specific Copperplate grid paper is available.

Copperplate is the first calligraphic hand I learned. I actually was disappointed that it looked so much like handwriting, didn't use a chisel tip pen, and wasn't Gothic. As it turned out, it was a perfect starting place for me. It has become one of my favorite styles of writing.

ESSENTIALS
Pen - Flexible pointed pen nib in an oblique holder
Spacing - At a 3-2-3 ratio, the x-height is 2 and extenders are 3; at a 2-1-2 ratio, the x-height is 1 and extenders are 2.
Weight - Determined by the pressure
Slant - 25 to 35 degrees from the vertical

Left: Menu by Molly Gaylor done in Copperplate alphabet.

Opposite page: Bookmarks by Patti Peterson; small envelopes by Carol Hicks; large envelope by Xandra Zamora; poem by DeAnn Singh.

May nothing trouble you;
may nothing frighten you;
everything passes;
God does not change,
patience overcomes everything
for those who have God.
Nothing is lacking.
Just God is enough.

Santa Teresa de Jesus

Linda

Dr. and Mrs. Robert Mountain
9709 Braddock Road
Rancho Cascades
California 51358

Sharon

Mr. Noah Breman

Using the Oblique Pen

Copperplate and pointed pen variations are written with a pointed pen nib in an oblique pen holder.

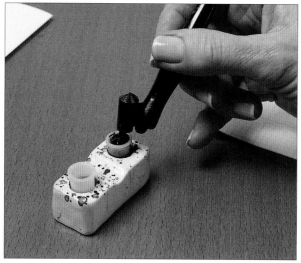

1. Dip the point of the pen in a small container of ink.

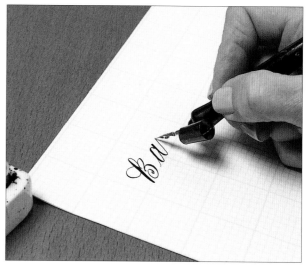

2. Put pressure on the down stroke and release on the upstrokes to get the thick and thins of the letters.

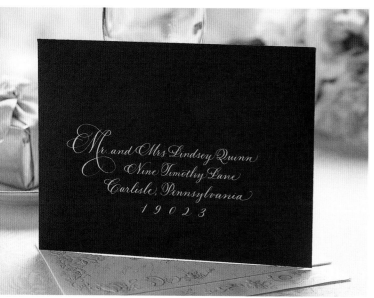

Above: Calligraphy by Xandra Zamora.
Copperplate alphabet, white ink on black envelope.

What pen?

The exemplar on the next page was done with a Hunt 99 for small letters and a Brause steno nib for the capitals. The nibs were held in an oblique pen holder.

On the following pages: Copperplate worksheets by DeAnn Singh.

Copperplate Comments

- *Copperplate has a wonderful press, release, press rhythm in the writing and is one of the most gratifying to write.*

- *Choose a flexible pointed pen, pencil, or fine tip marker to practice Copperplate. Try different writing instruments on different papers to find the right one for the job.*

- *Keep your pen pointed in the direction of the slant lines with the reservoir pointing up so the nib is efficient in its flexibility. Otherwise it will wear out very quickly and catch the paper every time you attempt an up stroke.*

- *When using a flexible pointed pen be sure to have a contrast between the thick and thin lines for a beautiful effect.*

- *Keep an even "picket fence" spacing of the letters. The capitals and flourishes are used to add embellishment.*

- *It is important to use the right nib and fluid to write on certain papers - much more so than when writing with a chisel point nib. The nibs wear out and need to be replaced more often than a broad-edge nib. When the nib doesn't write very well anymore, check the nib with a magnifying glass. If the points are "tweaked" or you can see daylight between the tines, throw it away. It's not worth your time.*

Copperplate

35° slant to vertical

	1	2	3	4	5	6	7	8	9

BASIC STROKES

RATIO 1.5 - 1 - 1.5

a b c d e f g h i j k

l m n o p q r s t u

v w x y z & ✓ ℱ

2005

Copperplate

35° Slant to vertical

Ascender

square ends

start pressure

similar size

BASIC STROKES

Waist | 1 2 3 4 | 5 | 6 7 8 9

Base

Thick = down stroke

Thin = up stroke

All down strokes same width

try to make the same size

Same size as #2, 3, 4.

Start and end at 3:00

end pressure

full pressure

Descender

set·press· pull

keep inside the #3. same as #8

#8

leave space at entrance serif.

leave the curve of #8. Don't cover it with the #3

stop then lift.

#4

cross just before baseline

a b c d e f g h i j k

wrong arch right arch

Roman arches Don't curve too soon.

a little taller

above waistline

taller

l m n o p q r s t u

Same size

start curve high enough

exit at 3:00

#4

Don't quite touch

lift pen for exit serif.

#9 is inside the #4.

v w x y z & ...

exit at 3:00

WRITTEN WITH HUNT 99 NIB

2005

Capitals

RATIO 2·1·2

Ascender Primary Stem Stroke — no pressure

pressure

Waist terminal dot

Base no pressure

Stroke with heaviest pressure

Secondary Stem Stroke — less pressure — same or less than primary

Make all flourishes BIG compared to the letter.

Capitals are based on ovals. Keep them in correct proportion.

Descender

A B C D E F G

H I J K L M N O

P Q R S T U V W

X Y Z 1234567890?!" "

The quick brown fox jumps over the lazy dog.

Mr. & Mrs.

2005

POINTED PEN VARIATIONS

The pointed pen is versatile. These variations of Copperplate employ pressure on the down strokes and release on the up strokes. The pointed pen also can be used for tiny writing or drawing. For tiny writing, maintain a very light touch, even on your pressure strokes.

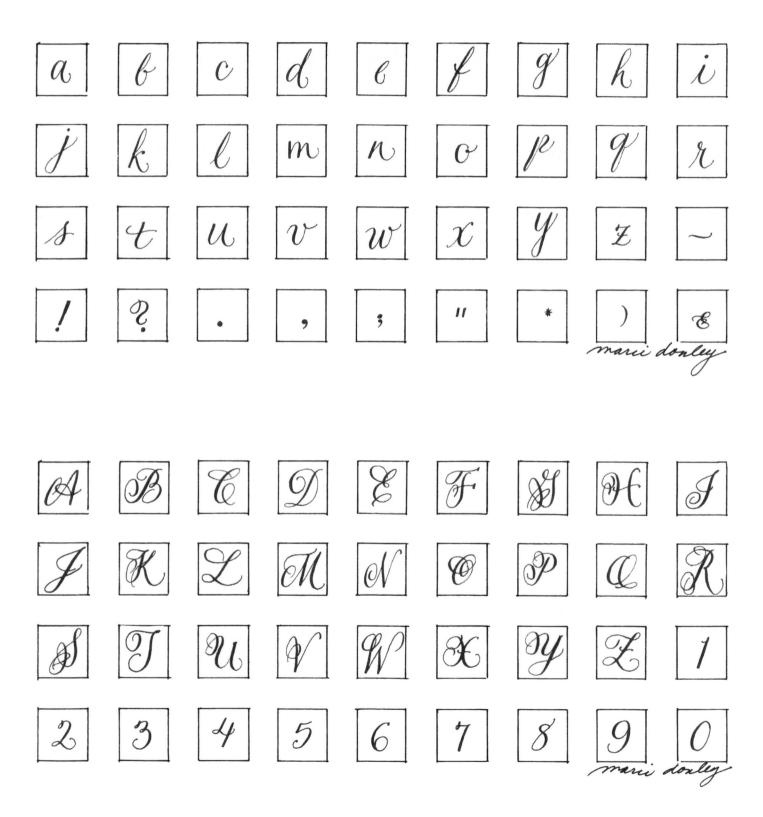

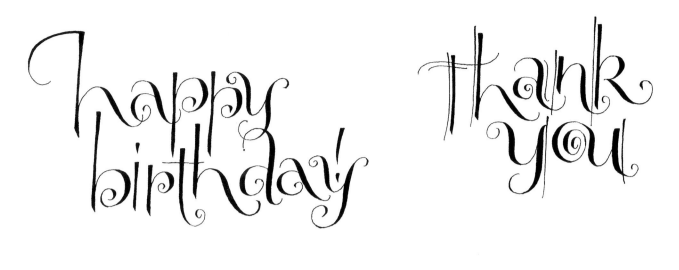

Happy birthday!

thank you

SPRING
SUMMER
AUTUMN
WINTER

Family vacation

happiness is...

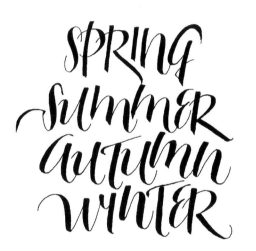

Halloween Party

Milestones

Celebrate

abcdefghijklm
nopqrstuvw
xyz

Happy Anniversary

Jane Shibata

FLOURISHING

Flourishing is the dramatic decorating that embellishes letters. To many people, flourishing *is* calligraphy - it's what everyone admires most and wants to learn. Flourishing is not easy, but you can learn how if you have patience. A steady, relaxed hand is helpful for your successful flourishing. Keep practicing, and eventually you will be a master flourisher.

The hallmarks of a good flourish are a natural gesture and no dark spot on the page. If the mark you make is sketchy or shaky, stiff, or too small, it won't make a good flourish.

Some Elements for Flourishing

Cards by Joan Hawks

- **Ovals** - Make ovals of every size and direction - vertical, horizontal, diagonal. There are wide ovals and narrow ovals. Ovals can be written clockwise or counter clockwise.
- **Figure 8s** - Figure 8s have all the same possibilities as ovals.
- **Circles** - Circles can be done clockwise or counter clockwise.
- **Direction changes** - Direction changes come by way of a small loop, full stop, or small turn around.

Practice these elements over and over with a pencil on scratch paper while you are talking on the phone and need to doodle. It will make them come naturally off your fingertips. Do them in the air with your whole arm. Combining these elements will make beautiful and natural marks on your page.

This lesson illustrates typical flourishing that can be used for Copperplate; the techniques work for Italic as well. If you are writing in Italic, don't forget to keep your pen angle at 45 degrees.

I find it helpful to draw the flourish in pencil because it flows easily. Before you write over the pencil with ink, practice a few times with the pen in your hand and no ink. Then dip your pen, blot, and put the pen down and make the flourish. Don't worry if you don't stay on the line, just use the line as a guideline - the flourish must be free, not stilted. Take a big breath or two before you begin a flourish to help you relax and focus. Every now and then check your breathing to be sure you aren't holding your breath. When you erase the pencil no one will ever know where the line was.

Direction changes add an extra something to the flourish, making the letter more contemporary and interesting. Be sure to not repeat the same flourish too often in one piece; you need contrast to create interest. Most of all, don't create dark spots by making the flourish too small or too close to some other line. Don't cross too many dark lines; if you see it coming, make sure that stroke will be thin. Don't let too many lines converge in close proximity.

Many calligraphers use a smaller nib for flourishes. The smaller nib reduces the chances of heavy dark spots and leaves a little more space. Practice, practice and, when in doubt, don't flourish. A clean piece of writing is better than a tangle of lines. Have fun!

Flourishing

Th Th th th love

tti off t t ssss

g y j p j

h g be ll g

Elements of flourishing: Ovals, Figure 8, Circles, Direction changes.

99

2005 Singh

Use the elements of flourishing to add pizzazz or definition to your words. It's not easy, but you will do your best if you can relax. Try to loosen up and play with framing and decorating your words with a flourish. It helps to breathe and think of letting the pen dance in your hands.

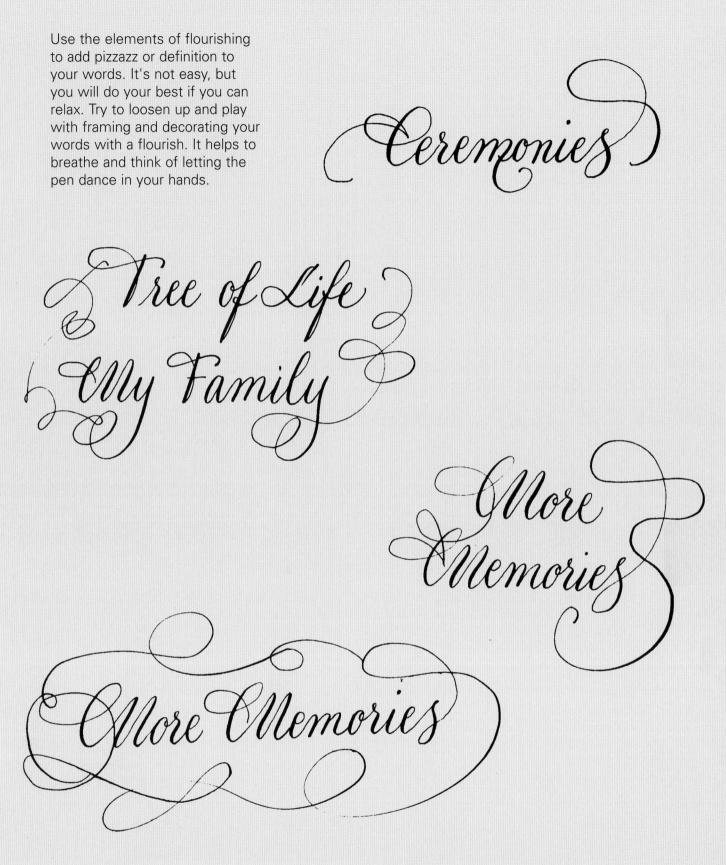

Pictured opposite page: Calligraphy by Xandra Y. Zamora. Cards and invitations lettered in jet black gouache with pointed pen.

100

Mr. and Mrs. Sol Ickovitz
request the pleasure of your company
at the marriage of their daughter

Lisa Michele
to
Tarren Miller

son of Dr. and Mrs. Allan Miller

Saturday, the twenty-third of August
Two thousand and three
at seven o'clock in the evening
Skirball Cultural Center
Los Angeles, California

Reception to follow

Constance Anne Sommer
Kenneth Donnellon and Ann Baxter
request the pleasure of your company
at the marriage of their daughter

Anne Elizabeth Donnellon
to
Walter Rodney Burkley III

Saturday, the thirtieth of October
Two thousand and four
at half past three
Saint Monica Church
Santa Monica, California

Wishing you lots of love, giggles, and good times this holiday season

Lisa, Mark, Taylor, and David

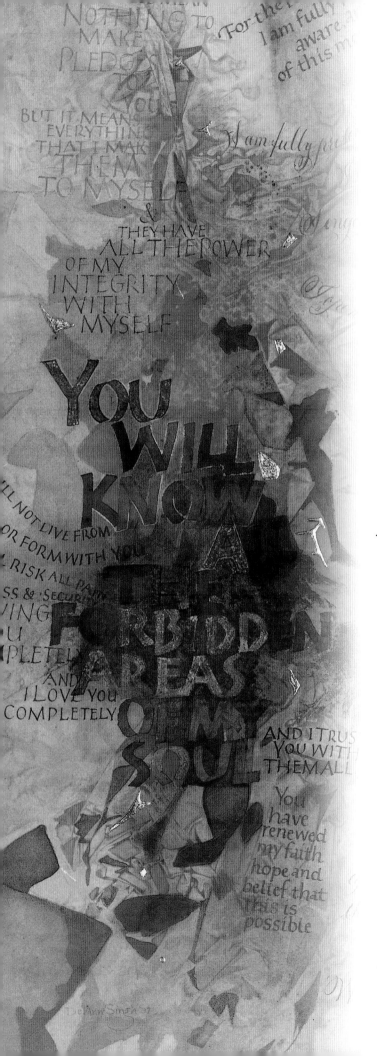

Tricks
of the
Trade

In this section, I share tips and ideas for correcting mistakes in your work (yes, you will make mistakes) and getting your lettering spaced correctly. Spacing is the most difficult aspect of calligraphy to master. You may not recognize good spacing when you see it because there is so much bad spacing all around us, particularly in computer-generated artwork.

Left: Calligraphy by DeAnn Singh, *Tom and Jane*, gouache on watercolor paper, pointed pen, broad edge nib.

Pictured opposite: Scrapbook pages by Marci Donley in Italic alphabet.

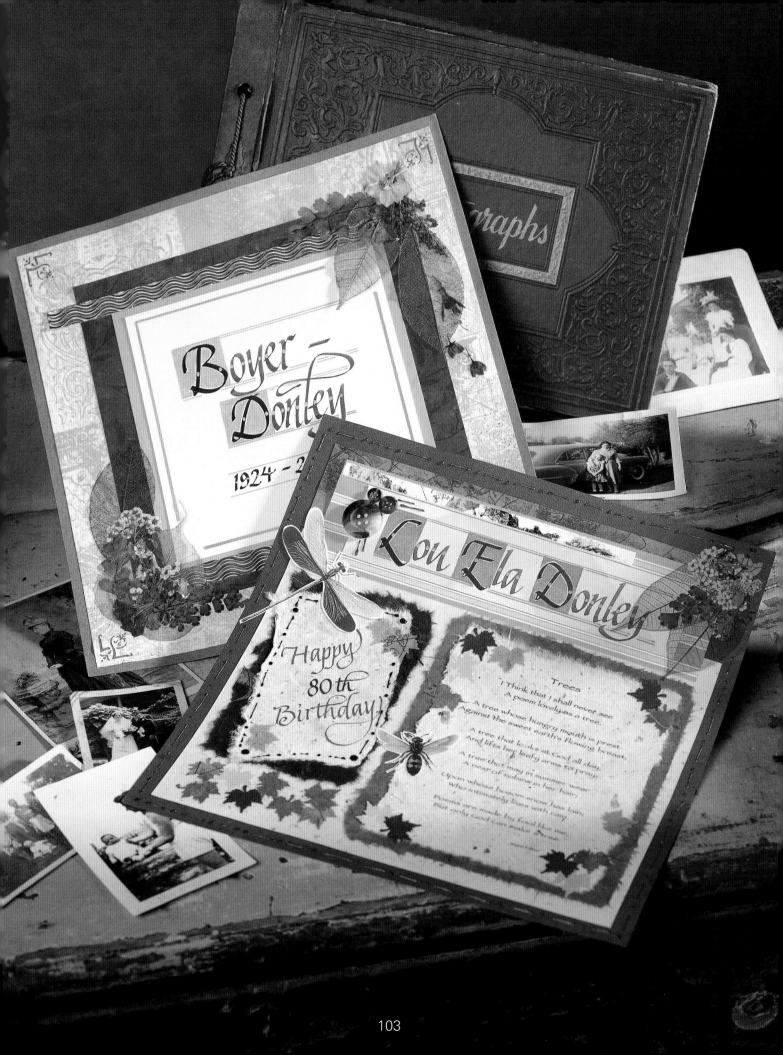

Correcting Mistakes

When something happens to your work that is unacceptable and will be noticed, you have two choices. You can either start over to make it right, or you can try to fix it.

I much prefer to try to fix it. I have become a bit of a master of fixing things up because I make many mistakes, and I don't much like starting over. I have a motto: "If you can't fix it, feature it." In other words, make the mistake work for you.

Sometimes a mistake forces you to solve a problem that ends up "making" the piece. I wish you many happy mistakes. Here are some ideas.

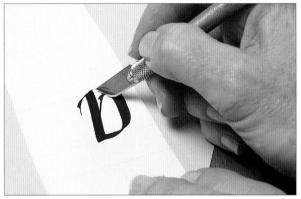

Photo 1 - Using a craft knife to remove an error.

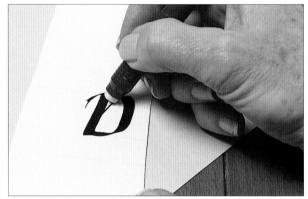

Photo 2 - Erasing a mistake with a white eraser.

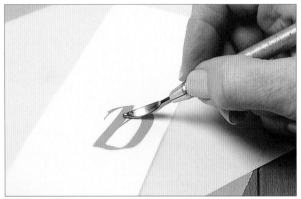

Photo 3 - Burnishing the paper to smooth it.

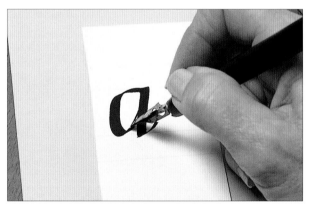

Photo 4 - Correcting the mistake.

Take it off. If you get a tiny bit of paint where you don't want it, you have options. You can try lifting the paint off with a toothpick while it's still wet. (This can be tricky.) You can also let the paint dry and carefully scrape it off, using a craft knife with a rounded (#10) blade. (**photo 1**) This may not work at all if you have used a marker, but since paint sits up on top of the paper, you can scrape it off, tiny bit by tiny bit. You could also erase the mistake with a white eraser (**photo 2**). You may find alternating scraping and erasing does the trick.

When the paint is gone, burnish the paper through a piece of glassine (**photo 3**) to form a new, clean writing surface. (I often use the envelopes I get from the post office when I buy stamps.) Then make the correction, using a controlled amount of paint or ink until you determine how the paper has been affected (**photo 4**).

Soak it up. If you get too much ink on your pen and you have a puddle in the stroke, roll a piece of tissue between your fingers to form a tiny wick. Carefully place the wick in the puddle of ink to draw some of it out.

Calligraphy by Marci Donley, brush markers and colored pencil on watercolor paper. Letters are outlined.

The artist wrote the word "gift" in the wrong color for her design idea.

To make the correction, she cut and pasted an illustration of a "gift" resulting in a more interesting piece than the original idea.

Calligraphy by Patti Peterson

Outline the letters. You can use a dark outline to add definition to the shape of a letter that may be a bit off. (Outlining also helps letters pop off the page.) You can do outlining freehand or use a ruler and a pen - this works particularly well with straight-sided letters like Gothic.

Cover it up. If you make a mistake in a body of writing and just can't fix it, consider covering it with another piece of paper. Simply pick a featured word or image and mount that on top of the mistake. If you mount the paper piece with dimensional dots, you can make it seem intentional. (You can also work like this intentionally to make an interesting design. It takes the pressure off if you only have to do a portion of the piece at a time.)

Another way to cover mistakes is to use a collage technique. Never underestimate the power of a well-placed sticker, glitter, ribbon trim, tag, embellishment, or leaf - the list goes on and on.

Let it go. Some mistakes will never be noticed. For those, my advice is: Take note, don't do it next time, and continue. Just get over it and move on. Sometimes you just have to finish the darn thing, perfect or not.

SPACING

Every time I put pen to paper I think about my spacing and try to make it perfect, but there are times my efforts fall short. Getting it right is an ongoing process. Embrace this process and enjoy the meditative part of the brain-body connection.

Here's the best advice I ever got about spacing: Look at the space you just created and create the next space with one that is similar. Don't forget to watch the space that you are creating inside the letter you are forming. Consider both the outside space and the space inside the letter.

I I	HR	/ /	AW	Two straight strokes or two diagonal strokes are further apart.
) I	OR	\ I	AM	A curved stroke and a straight stroke or a diagonal stroke and a straight stroke move closer together.
) C	OC) \	OW	Two curved strokes or a curved stroke and a diagonal stroke are closest.
HILL		AWAY		
HOP		WIN		
DOOR		ACE		

Types of Spacing

Letter spacing (refers to both the space inside a letter and the entire outside space it takes up)
Spaces between letters
Spaces between words
Spaces between sentences
Spaces between lines
The margins of the page

Different hands require different spacing. Picket fence spacing - where the inside space of the letter is the same as the outside space - is used for Italic, Copperplate, and Gothic. Other alphabets have letters that touch between lines. Uncial letters are strings of pearls.

Basic guidelines for spacing can be applied to and adapted for each hand. When you combine letters, be especially aware of the spacing between the letters and the spaces inside the letters themselves. For your work to be pleasing to the eye the spacing needs to be uniform. When I'm writing a single word, I often try to work the spacing off the hardest combination. In a body of writing, try to be consistent and not to create any dark or light spots.

Here's a quick lesson: Use the italic lowercase "n" as a guide. The space in the middle of the two legs of the "n" should be about equal to the space between the "n" and the letter next to it. Most letters will take up about the same space as "n," except "m," "o," and "w," which are wider, and "i," "l," and "j," which are narrower. It is simple to place letters equally spaced next to each other as long as they are "a," "n," "h," "p," "k," "g," and similarly sized letters with straight sides. When you introduce letters with rounded or diagonal sides, think of the volume of the space between the letters and try to place them so that visually they appear to take up the same amount of space. The space between words should be the size of the entire "n."

Dots, dashes, lines, color, and design elements can all be used to distract the eye from spacing problems and visually correct them. For example, if you leave too much space between letters, you can add dots or dashes between

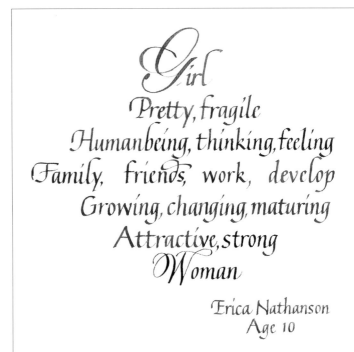

Calligraphy by DeAnn Singh, *Girl* done with mixed styles. The "G" and "W" are in Copperplate and the rest is in Italic. This requires some unusual spacing. Lettering done in gouache with steel nibs on watercolor paper. Notice how even the spacing is between the lines.

them. Or if your word has a gap in it, you can paint a leaf or a flower and tie in the design as you close the gap.

A good way to check your spacing is to prop up your work, step back, and look at it through squinted eyes. You shouldn't see any dark or light spots that aren't part of the design.

The Role of Design

This is not permission to have bad letterforms or spacing, but be aware that your layout and intention are more important than actual lettering perfection. A great layout with not-so-great letterforms will look better than great letters with no design.

Marci Donley's *Alphabet Book*, written with Monoline pen, square stamp pad, paint.

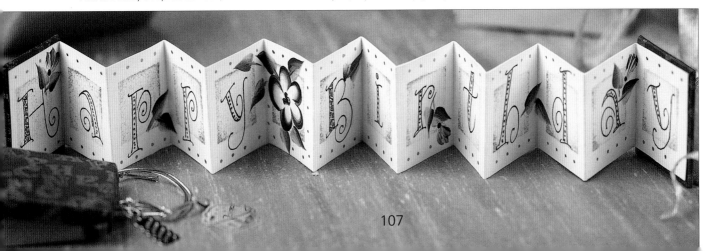

Getting Creative

Once you learn the classic alphabets, you'll begin to discover ways to enhance your calligraphy and letters. Some projects call for perfect, beautiful letters and an elegant look. Other times you may want to add playful elements.

Now it is time to loosen up, play with the tools, and get comfortable with your new skills. This section contains a wealth of techniques and ideas for adding pizzazz to your work. Relax, breathe, wave your arms in the air, shake your hands, and get ready to take some liberties.

Left: Creative lettering by Marci Donley done with pointed pen variations.

Right: ABC book by Sylvia Kowal. Watercolor paper was stained with walnut ink. The calligraphy was done with bleach used in a ruling pen.

USING A RULING PEN

Ruling pens are drafting tools intended for drawing lines. Also called folded pens, they are used a little differently than regular pens. They make wonderful marks and can be used for interesting creative letters when you use the broad side on down strokes and the narrow tip on the up strokes. They can add an uneven, interesting texture to your letters that gives meaning, motion, and expression to your work.

In these photos, I'm using the moth pen made by Jim Chin.

1. Dip the pen into a small container of ink or paint.

2. Make the downstrokes with the large side of the pen. Notice the texture. It's okay to be uneven with this tool.

3. Come up on the tip for the upstrokes to get more extreme thicks and thins.

USING POSTER PENS

A pen with a very large nib is called a poster pen. There are many types of these pens. My favorite poster pen is the automatic pen.

An automatic pen can give you many looks if you use the various edges of the pen to produce different effects. Experiment with poster pens to see which effects appeal to you.

Double-colored Letters

Take a small piece of sponge and cut it to fit inside the nib of the automatic pen. This will act as a reservoir. If you dip one side of the pen in one color ink and the other in another color, you can make double-colored letters.

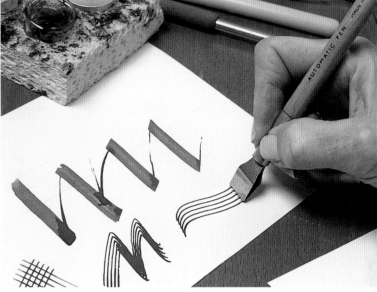

Using an automatic poster pen. This one is called a music pen.

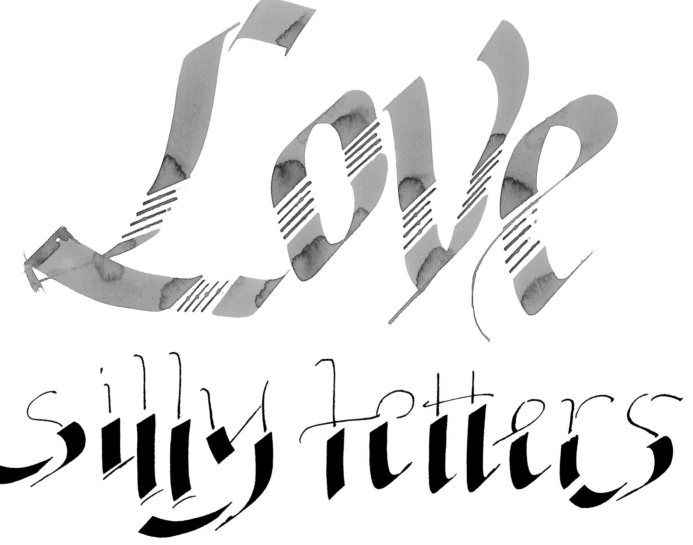

BRUSH LETTERING

Painters will like this alphabet. It's written with a pointed brush - you get the thicks and thins of the letters by changing the pressure you exert on the brush (just as you do with a pointed pen).

Brush markers and brush pens make this type of lettering very easy if you prefer to work with them.

1. Using the side of a brush marker for the thick down stroke.

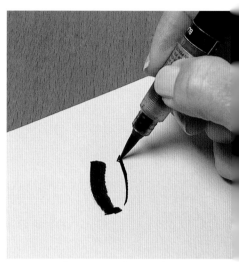

2. Using the point of a brush marker to make the thin up stroke.

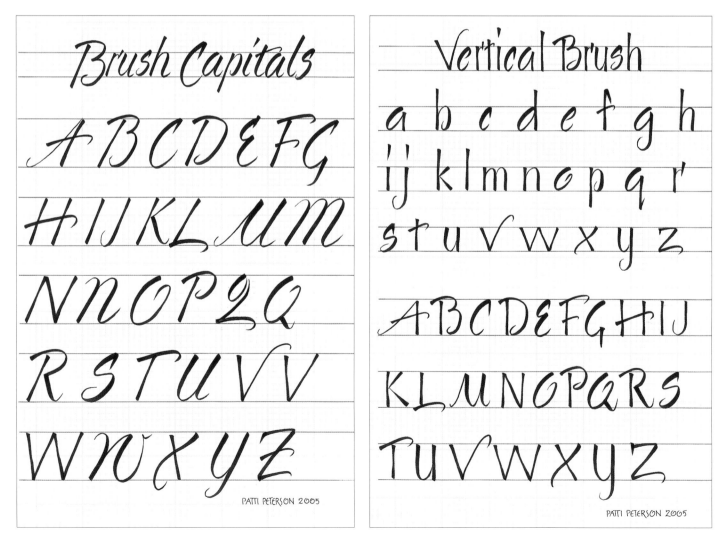

Brush Capitals

A B C D E F G
H I J K L U M
N N O P 2 Q
R S T U V V
W N X Y Z

PATTI PETERSON 2005

Vertical Brush

a b c d e f g h
i j k l m n o p q r
s t u v w x y z

A B C D E F G H I J
K L M N O P Q R S
T U V W X Y Z

PATTI PETERSON 2005

112

Brush Lettering

BASED ON PRESSURE AND RELEASE STROKES

press ↓ ↓
a
release ↑ ↑

press ↓ ↓
u
release ↑ ↑

press ↓ ↓ ↓
w
release ↑ ↑ ↑

press →
b release
press
release

flick
i press
release

press + flick
" press → release

a b c d e

f g h i j k

l m n o p q

r s t u v w

x y z

MONOLINE LETTERING

Monoline letters allow you great flexibility. You can use a variety of writing instruments, from formal steel nib pens to simple markers, to create interesting alphabet variations with whimsical additions and flourishes.

Basic Monoline Roman Caps

Roman capitals provide the basis of the size, shape, and ductus of this alphabet. It is a modified version of the alphabet used in ancient Rome that has been updated for pen writing. The Roman alphabet is divided into families by the size of the letters. The proportion of the letters to each other is very important for the look.

ABCDEFGHI
JKLMNOPQ
RSTUVWX
YZ

Monoline Roman Capitals
B-5½ Marci Donley

ABCDEFGHI
JKLMNOPQ
RSTUVWX
YZ

Monoline Roman Capitals
B-5½ Marci Donley

Monoline Whimsy

This alphabet starts as a spiced up variation on the classic Italic alphabet and uses the rules and ductus of the formal Italic alphabet. It's fun to draw with a monoline pen. When you've mastered the basics, try adding bits of color or design elements or build up the lines to make them even more playful.

Start with a basic skeleton of the Italic alphabet. I like to work in monoline pen or pencil for this step.

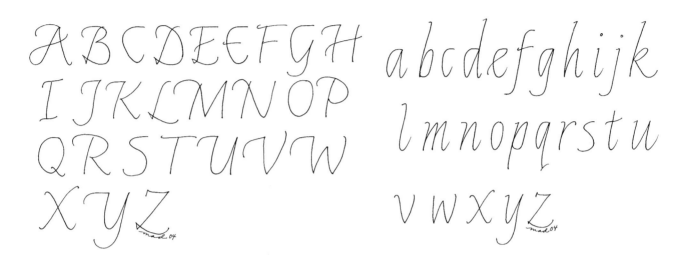

Next, simplify the shapes and build up the stem strokes in the skeleton alphabet.

Monoline Lettering, continued

Altering Monoline Alphabets

For a distinctive look in a block of text, choose a specific letter (or letters) of the alphabet, such as an "o" (or "o" and "q"). Change that letter every time it appears.

Or try this technique and the letters "s" and "t." Make the "t" very tall or short or exaggerate the top. Make the "s" very round, or with hardly any curves. Here are some ideas.

Try making the "o" and the "q" very large and round.

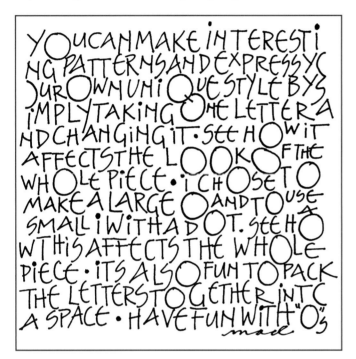

Try making the "o" small, and put a dot under it. Use a dot the same size to dot the "i."

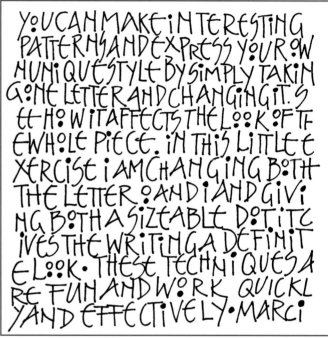

Use a spiral as a variation on the letter "e."

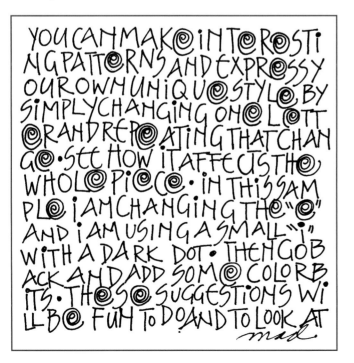

Add some color. Get out markers or watercolor pencils and color in some of the shapes.

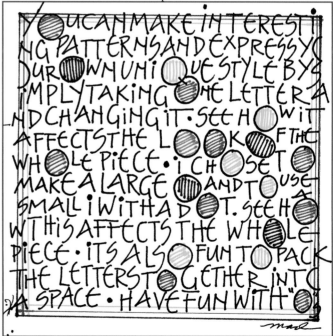

Fill in each tiny "o" in one color. Fill in each "d" in another color. Add a simple line border.

Use three colors of watercolor pencils to fill in some spaces. I chose to enhance the linear aspect of the piece and fill in space on every other line. I used red to accent the dots of each "i," the center of each spiraled "e," and the periods.

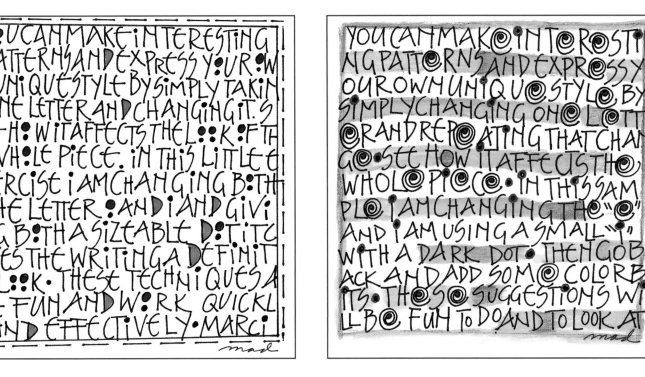

Right:
Marci Donley,
Whimsy
letters,
monoline pen,
watercolors
used to fill
letters

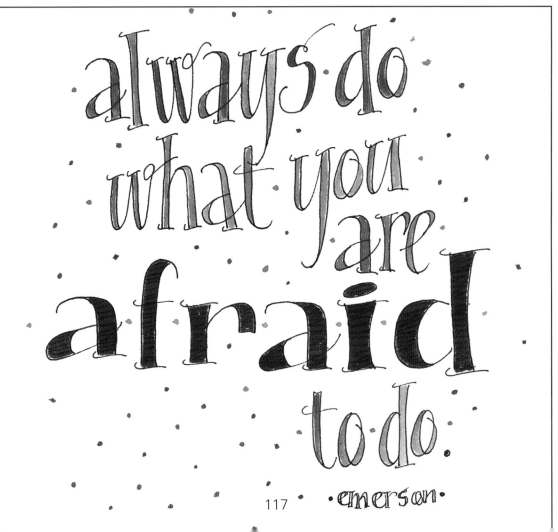

DIMENSIONAL PAINT WRITING

Dimensional paints can be used to create raised letters and texture. They come in plastic squeeze bottles that have applicator tips so you can use them right from the bottle. Dimensional paints are available in an array of colors and can be used for shiny, metallic, glitter, neon, and pearl effects. Find them at crafts and art supply stores. Follow the manufacturer's instructions regarding curing time.

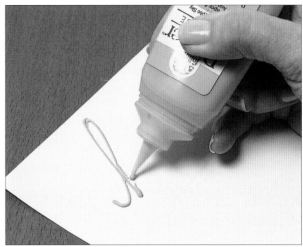

Writing with dimensional paint. Put even pressure on the tube and use the tip as you would a pen or pencil.

Here are some tips for achieving good results:

• Hold the bottle just slightly above the work. Give even pressure to the bottle as you form the letters or design.

• Try to work with the tip of the bottle ahead of the paint. Pulled strokes look much nicer and are easier to execute than pushed strokes.

• Follow the ductus on the exemplar.

• Lift the bottle straight up as you exit from a line or dot and watch to be sure the paint separates from the bottle.

• Wipe the tip of the bottle frequently.

• Have cotton swabs and toothpicks handy to fix any unintended paint drips.

• For fine details, add a metal tip to the bottle to give a finer line.

• The paint will flow together if lines of paint are placed too close together. (TIP: Experiment and see just how close is too close.) If you want your accents to be separate, place them away from other colors.

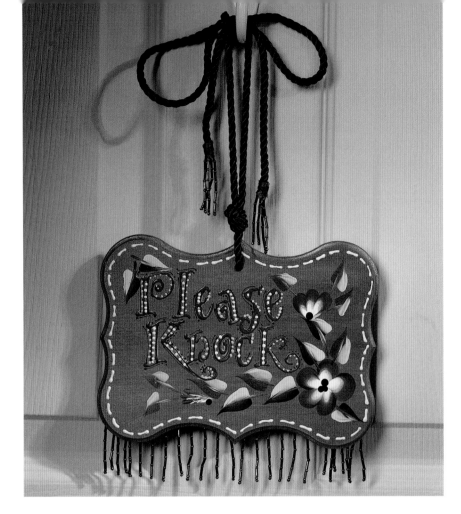

Dimensional paint was used on wood to create a door sign, a luggage tag, and a monogrammed round pin attached to a greeting card.

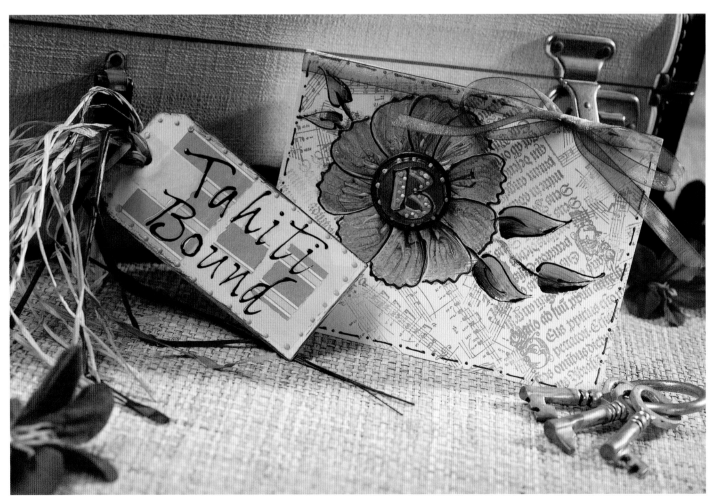

HEAT EMBOSSING

Heat embossing is another way to add dimension and special effects to calligraphy. You write the letters with a pen that contains slow-drying ink, sprinkle it with embossing powder, shake off the excess powder, and heat the powder that sticks to the ink with a special heat tool. The result is a raised letter with a shiny surface.

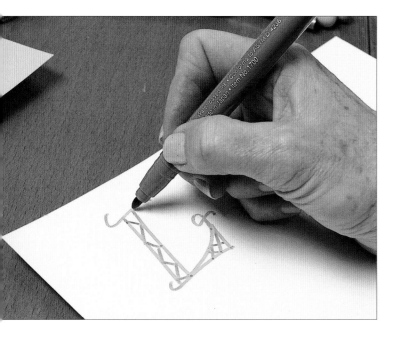

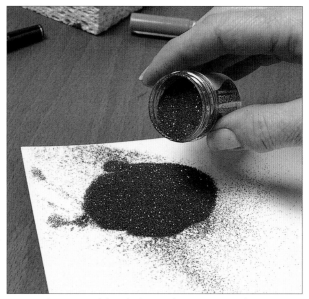

1. Write the letter, using an embossing pen. (You can also use almost any ballpoint pen for embossing.)

2. Working quickly, shake embossing powder over the wet ink.

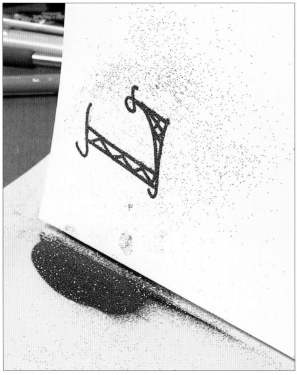

3. Shake off the excess powder onto a sheet of paper. Use the paper to place the powder back in the container - the loose powder can be used again.

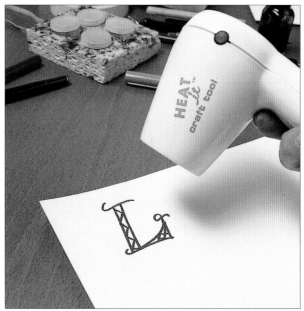

4. Heat the image with a heat tool until the embossing powder melts and makes a raised, shiny surface. Don't touch until it cools off.

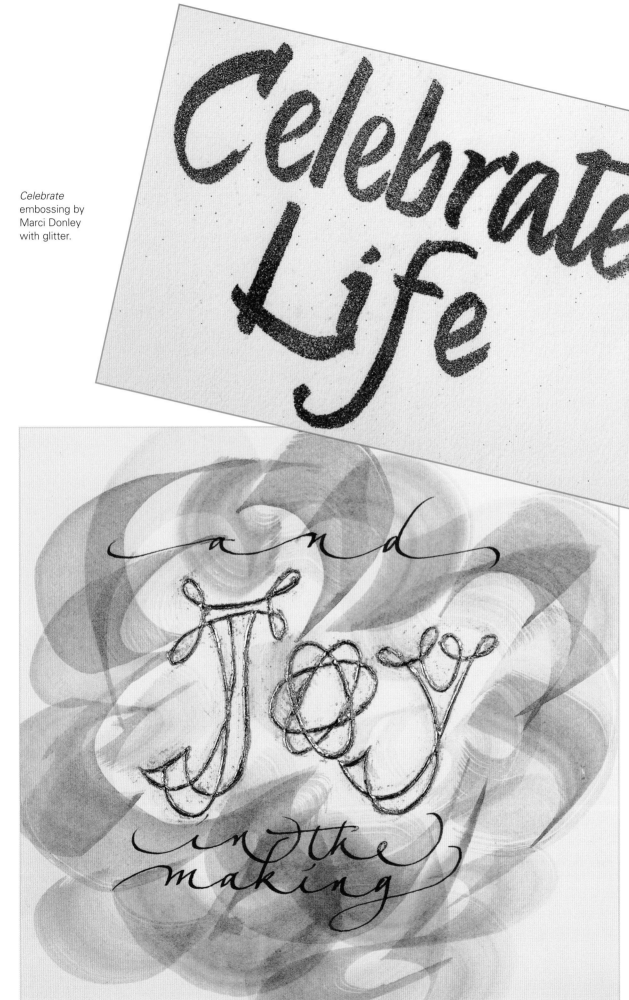

Celebrate embossing by Marci Donley with glitter.

Joy gold leaf embossing on a painted background by Carri Imai.

CREATING BACKGROUNDS

Letters look great on backgrounds. You can paint a patch of color, create texture with a sponge, or make background textures by writing huge letters or tiny letters in pale ink. Illegible writing makes wonderful patterns and textures, and even scribbling can be interesting when used as a background. Or use your computer to print a background such as a map on your paper and do lettering over it.

> **TIP:** *Keep your rejects! Save your work even if you aren't satisfied with it. Give it new life by using it as a background for other work. You might be pleasantly surprised.*

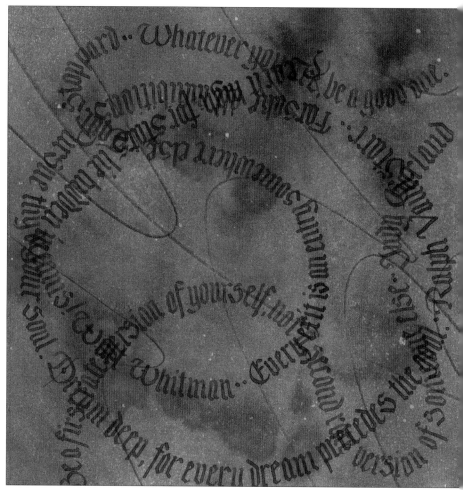

Calligraphy by Sylvia Kowal. Done with walnut ink on watercolor paper that was painted with walnut ink.

MIXING COLORS

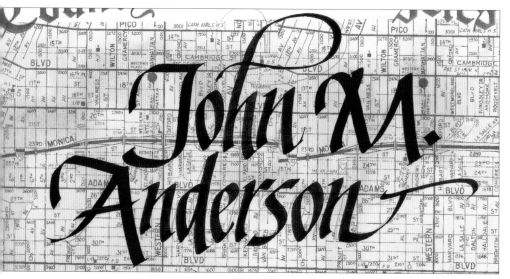

Mix colors when writing a name. Make the capital letters in one color and the lowercase letters in another color.

Left: Calligraphy by Marci Donley, map background with watercolor wash, colored capitals.

DECORATING THE LETTERS

Fill the spaces inside capital letters with gold or another color. Add dots on the letters. Make a square or circle around a capital to make it stand out.

You could also build up the letters and decorate them with dots, leaves, and monoline pen embellishments.

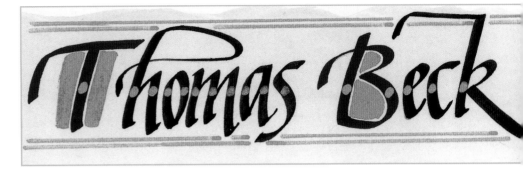

Pictured above: by Marci Donley, filling in capitals.

Pictured left: by Marci Donley, drawn letters with leaves and dots, built up.

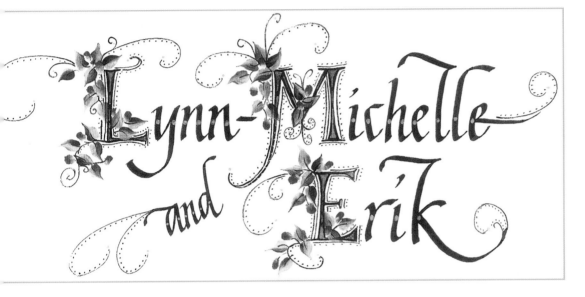

ADDING SHADOWS

Adding a drop shadow - an old sign painter's trick - can add dimension to your work. Be sure to place the shadows consistently on one side.

Listen with Your Soul by Carrie Imai. Done with gouache using a steel nib.

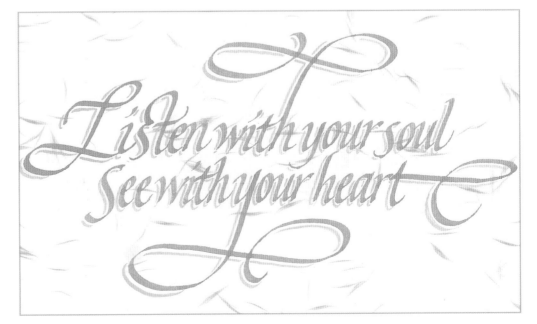

CREATING YOUR OWN ALPHABET

Once you get very good (or, as one teacher said, "when you grow up"), you may enjoy creating your own alphabets. A good place to start is a simple monoline whimsical alphabet. You can also use your own handwriting as a starting place (more about this on the next pages) or, if you see a style of writing you like, you can create your own exemplar from a sample word or a few letters.

I was taught to think of letters in an alphabet as family members. Certain letters look alike as family members do. There should be a resemblance; if there isn't, it's noticeable. The capital letters are one generation of a family (the mother and father); their kids, the lowercase letters, should resemble them.

To create an alphabet family, begin by reproducing the letters represented in your sample word, then fill in the rest of the alphabet by creating letters that go together and resemble each other. For example, form the lowercase letter "d." Follow with the lowercase "a" and "n" - they should echo the shape of the "d." The branching letters should go together and form a family. Keep refining your alphabet until it works.

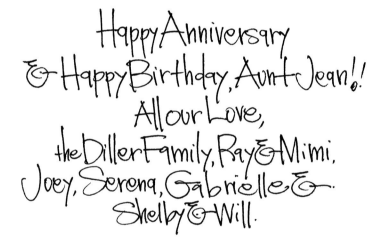

ENHANCING YOUR OWN WRITING

To make your own handwriting work for you, find something about it that you can exaggerate as a style element. To illustrate, here's an example of my handwriting and the steps I took to enhance it using the words "The Unexpected."

I exaggerate some letters a bit.

Then I added some decorative embellishments.

And then I added even more decorative bits.

As you continue, you can add more decoration and fix any parts you are not yet pleased with. I was unhappy with the decoration on the "c" so I played a bit more.

Keep experimenting, have fun, and explore your ideas. Stop when you are happy with the result or you just can't go any further!

Metric Conversion Chart

Inches to Millimeters and Centimeters

Inches	MM	CM	Inches	MM	CM
1/8	3	.3	2	51	5.1
1/4	6	.6	3	76	7.6
3/8	10	1.0	4	102	10.2
1/2	13	1.3	5	127	12.7
5/8	16	1.6	6	152	15.2
3/4	19	1.9	7	178	17.8
7/8	22	2.2	8	203	20.3
1	25	2.5	9	229	22.9
1-1/4	32	3.2	10	254	25.4
1-1/2	38	3.8	11	279	27.9
1-3/4	44	4.4	12	305	30.5

Yards to Meters

Yards	Meters	Yards	Meters
1/8	.11	3	2.74
1/4	.23	4	3.66
3/8	.34	5	4.57
1/2	.46	6	5.49
5/8	.57	7	6.40
3/4	.69	8	7.32
7/8	.80	9	8.23
1	.91	10	9.14
2	1.83		

Index

Index

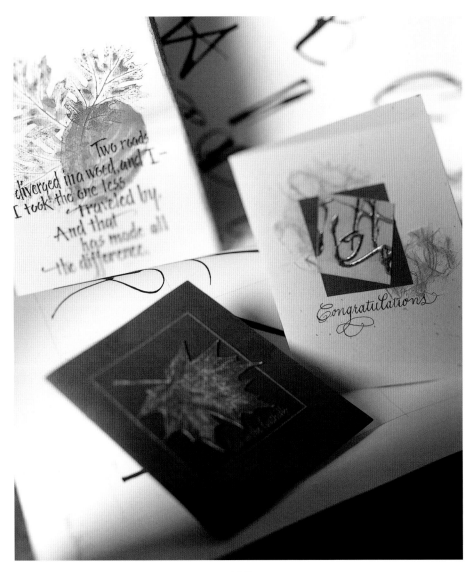

About the Author

Marci Donley has been involved in arts and crafts for over fifteen years. She entered the world of crafts unsuspectingly when she was asked to help out at a gift show for All Night Media. That invitation was the beginning of a full time passion and career path, with rubber stamping leading to calligraphy, which led to book arts, paper crafting, and painting.

Always on the lookout for new techniques, Marci embraces the challenge of using new materials for artistic expression. She enjoys spending time making artist books, art for framing, collage, cards, and miniature anything. She loves the creative process of bringing all the arts together.

Marci is a calligrapher for the Supervisors of Los Angeles County, teaches calligraphy and rubber stamping, and is a One Stroke Certified Instructor and an Ambassador for Plaid Enterprises. Her work has been featured in several books published by Plaid, and she collaborated with Donna Dewberry for the book, *Outdoor Greetings*, combining her lettering techniques with One Stroke painting. Marci is the co-author (with Mickey Baskett) of *Greeting Cards Galore* (Sterling, 2004).

Marci is a native of Los Angeles where she and her husband, David, share a California Craftsman home. She is the proud mother of two sons.

ACKNOWLEDGEMENTS

I have found calligraphers to be a very giving group of people. Generally they are happy to share their techniques with you. I am lucky to have found calligraphy and to have made so many friends.

I thank the following artists, friends, and teachers for sharing their work with me for use in this book. I could not have done it without them:

DeAnn Singh	Xandra Zamora	Joan Hawks
Alice Greenthal	Carol Hicks	Fred Tauber (In
Virginia Farr-Jones	Sylvia Kowal	Memorium, with
Carrie Imai	Patti Peterson	many thanks for the
Jane Shibata	Molly Gaylor	early inspiration.)

I thank the teachers who gave me so much and left everlasting impressions on me: DeAnn Singh, Marsha Brady, Reggie Ezell, Thomas Ingmire, Peter Thornton, Carrie Imai, Carol Palleson, Melissa Dinwiddie, Eliza Holliday, Jean Formo, Rosie Kelly, Carl Rhors.

I also thank my husband David for all his help and support with this project. He helped keep me accountable and on task, even though I wasn't always happy about it. And thank you to my family for allowing my absences when I was only halfway present.

ORGANIZATIONS FOR CALLIGRAPHERS

The artists who contributed to this book are members of the Society for Calligraphy in Los Angeles, California. If you like calligraphy, you might like to join a guild. There are many in the United States and internationally. You don't need to be a seasoned calligrapher to enjoy the camaraderie, workshops, and exchange of information. For information, contact the Society for Calligraphy, www.societyforcalligraphy.org.